MYTHICAL
AND SPIRITUAL
TATTOO DESIGN
DIRECTORY

Russ Thorne

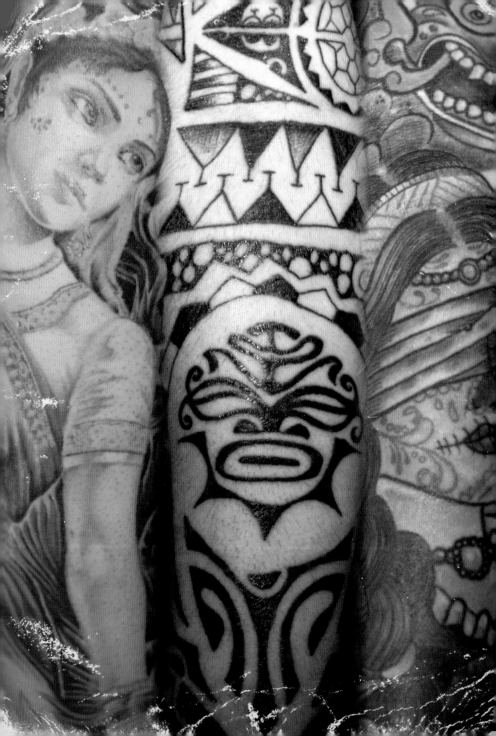

MYTHICAL AND SPIRITUAL TATTOO DESIGN DIRECTORY

THE ESSENTIAL REFERENCE FOR BODY ART

Russ Thorne

CHARTWELL
BOOKS, INC.

This edition published in 2011 by
CHARTWELL BOOKS, INC.
A division of BOOK SALES, INC.
276 Fifth Avenue Suite 206
New York, New York 10001
USA

ISBN 10: 0-7858-2715-3
ISBN 13: 978-0-7858-2715-3

QTT.STAD

A Quintet book
Copyright © 2011 Quintet Publishing Limited.
All rights reserved.

This book was conceived and produced by:
Quintet Publishing Limited
The Old Brewery
6 Blundell Street
London N7 9BH
United Kingdom

Project Editor: Martha Burley
Editorial Assistant: Nastasia Simon
Design: A&E Creative
Photographer: Scott Forrester
Art Editor: Jane Laurie
Art Director: Michael Charles
Managing Editor: Donna Gregory
Publisher: James Tavendale

Printed in China by 1010 Printing Ltd

Illustration credits
Michael Charles 57B; 58; 61T.

Danny Hirajeta 73T; 74B-L; 75; 77B; 86T-R; 103T,
C; 113; 141T, B-R; 143T; 144; 152T-R, C-L, C-R, B-L;
153C-R; 154B; 155T; 168; 173; 191T-R, B-L; 194; 195.

Emilie Jensen 87T, B; 102; 104; 105T; 145T.

Jane Laurie 33T-R, C-R; 53T, B; 73B; 74T-L, B-R;
77T; 79; 83B-L; 89T-R, C-L; 94B-L; 105B-R; 116; 117;
118; 119; 120; 121; 122; 123; 124; 125; 126; 127; 128;
129; 130; 132; 136; 137; 140; 145L; 147B; 149T-R;
162R; 188; 189C; 190T-L, C; 191T-L, B-R; 192; 193T-
L, B-R, B-L; 198.

Jon MDC 37 L; 38T, B; 39T, B; 42; 43; 68T, B; 69B-L,
B-R; 73C; 76; 80; 81L; 82; 83 T; 84T; 98L; 107T; 110;
111; 131; 133; 143B-R; 146; 147T; 156; 157; 163B;
165B-L, B-R; 166; 167; 189L; 219.

Juli Moon 89B-R; 91; 94B-R; 95; 96; 135; 154T; 158;
159; 174; 175; 179B-L, B-R; 181 T-L, T-R, C; 182; 183;
184; 186; 187; 189R; 190T-R, B-R; 193T; 211C, B-L.

Justin Nordin 29T-R, B-L, B-R; 33B-L, R-R; 35;
36C-B, B-L; 86C; 100; 101; 205; 206; 207; 208; 209;
211B-R; 213; 215; 217.

Stuart Thomas 29T-L; 30; 37T, B-C; 83B-R;
85T-L,T-R; 86L, B-C; 89B-L; 97; 98R; 99; 103B; 105B-
L; 106; 107B-L; 108; 109; 134; 162 L; 163T; 165T, C;
169; 170; 171; 178; 179T-L, T-R; 181B; 185.

Abby Wilson 52T, B; 54T, B; 55T, B; 56; 57T; 59T,
B; 60; 61B; 63; 65; 66; 67; 87T,B; 141L; 142; 143C-R,
B-L; 149T-L, B-R; 150; 151; 152T; 153T; 155B-R,
B-L; 211T.

Acknowledgments
Big thanks to everyone who shared their mythical
and spiritual tattoo stories with me, and to the
ever-patient and imaginative Quintet team—James,
Martha, Donna, Jane, and Michael—for getting me
involved in the first place. Love and thanks also to
my family and friends for their support, and my
fiancée Madeleine for putting up with a crazed
monkish tattoo loon. Finally, my own memorial
tattoo features in this book and commemorates the
life of my mum, Wahneta. Hope you approve, Ma!

contents

ABOUT THIS BOOK

"And this tattooing had been the work of a departed prophet and seer of his island, who, by those hieroglyphic marks, had written out on his body a complete theory of the heavens and the earth, and a mystical treatise on the art of attaining truth; so that Queequeg in his own proper person was a riddle to unfold."
—Herman Melville, *Moby Dick*, 1851

Throughout history tattoos and tattooing have held mythical or spiritual significance for people, signaling their faith, offering them protection, or providing guidance and inspiration from folk tales and mythology. It's no surprise that modern wearers are seeking the same thing, but with the wide range of tattooing styles and designs out there, where do you begin if you're looking for a tattoo based on faith, myth, or legend?

This book is here to help. It's designed as a starting point for anyone researching a mythical or spiritual tattoo, providing a guide to possible meanings of some of the most popular tattoo images; it also offers a host of original illustrations to help inspire you.

Given that religion has been around for quite a while, and that interpretations of myths, theology and images vary hugely, this book doesn't claim to be anything more than an introduction to a vast topic. It's definitely not a how-to guide to tattooing, a critique on world religions, or a spiritual guide—reading it will almost certainly not deliver you from evil or lead you away from temptation. But hopefully it will inform and entertain you enough to help you discover the styles and themes that interest you, and ultimately assist you on the road to your perfect tattoo.

NAVIGATING THE BOOK

PLANNING A TATTOO

The opening section looks at tattoos in general and provides a list of important things to consider when planning a tattoo. The main directory looks at specific faiths, symbols, and other elements of myth and magic, offering explanations of the designs and some of the history behind them. There's plenty to accommodate the tattoo fan or the curious reader, from tribal tattooing techniques to designs that make you bulletproof.

TATTOO DIRECTORY

Religious iconography, gods and monsters, angels and demons, fairies... it's all here. There's even a section on tattoo sins and noble truths—because although this book isn't intended to save your soul, it might just save your skin. Good luck, wherever your spiritual quest may take you!

ABOUT THE ART

All the tattoo designs in this book are original. They've been designed by real tattooists from all over the world and represent some of the very best in contemporary tattoo talent, so feel free to draw inspiration from them for your own designs. You can find out more about the artists themselves on page 220.

WHY GET A MYTHICAL OR SPIRITUAL TATTOO?

Illustrated by the myriad examples on the pages of this book, there are many reasons for choosing a spiritual or mythical tattoo.

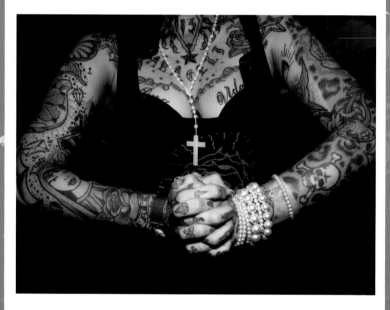

Tattoos can be a form of expressing your individuality, spirituality, and humilty.

It might be as a proud testament to your faith, or because you find certain mythological stories and characters appealing. Your tattoo may act as a moral compass, or it might encourage you to hail a fast taxi heading hellward. There is no one reason and no right or wrong—although you might want to consider some of the points detailed on pages 20–23.

TATTOOED PEOPLE: SARAH ROBSON

"I saw the face in a book of angels, but I didn't want just the angel because I'm very spiritual, so I put my own design onto it. It shows the spiritual side of me, and the good and the bad!"

TATTOOED PEOPLE: IRIS KNIPPELS

"My crow tattoo has so many different meanings, but for me it's the Native American folklore, where the crow is the trickster, showing you the good and bad ways of doing stuff. I also got it to remind myself to listen to my gut feelings more. It's only negative in Christian mythology, but in Norse mythology it's positive, almost a guide. Perhaps that's why I like it, it has this bad image that can be inaccurate—and I really love the bird, too!"

THOUGHT AND RESEARCH

Before you invite the tattooist's needle into your life—and skin— take the opportunity to think about why you want any kind of tattoo, irrespective of its mythical or spiritual significance. It's for life, not just for Christmas—or any other religious holiday for that matter—and is something that should be taken seriously. Even if the final reason for getting a tattoo is simply because you want one, you should still have thought about the possible consequences. For example, will you get bored of it? Is it in a highly visible place you'll later regret? What does it say about you? And have you been drinking today? If you have, don't go anywhere near a tattoo studio.

The first thing any decent professional tattooist will want you to

do is research your design thoroughly, and take your time deciding on whether or not to go through with it. This is because tattoo artists want people to go away happy, and to wear their work with pride for years to come, and it's good advice. You can absolutely get a tattoo on a whim, but it's almost always better to go home, think about it, and return in a month if that whim hasn't gone away.

MYTHICAL AND SPIRITUAL TATTOOS

So why a mythical or spiritual tattoo? It could be for one of the reasons mentioned above, or you might find a different motivation. Perhaps your faith is newly found and you want to celebrate it, or perhaps a particular mythical creature embodies qualities you'd like to see in yourself. An even more intriguing idea is that while for some people a tattoo is a way of decorating their body, for others it's actually a way of uncovering something that is already there, such as a deeply held set of beliefs, or a long cultural heritage stretching back into the distant past. You might look to your tattoos for protection, or they might remind you of a difficult period that you have emerged from, wiser and stronger.

Whatever your reason, you're in good company. We've been marking ourselves with spiritually resonant images for thousands of years. Tattoos have been found on a Copper-Age man entombed in glacial ice, and on Egyptian mummies. They've been mentioned in the Bible and in the journals of explorers, conquistadors, and anthropologists. Pilgrims were tattooed to prove they'd made it to the Holy Land, warriors sported representations of their

TATTOOED PEOPLE: JASON THOMPSON

"I'm getting a Tibetan-style sleeve and this is the *Devanagari* script for *om*, to tie it all in together—and also the symbol does look good on skin. I'm pretty laid back and I don't believe in God, but I definitely believe in the spiritual world; I'd like to think there was an afterlife."

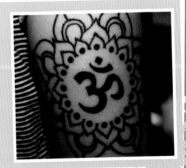

TATTOOED PEOPLE:
NANNA

"I have seven rings with seven petroglyphs (rock carvings), including the tree of life, Odin's boat, and a man with a sword who I call the 'happy man.' You have the sun and moon boats, and the woman skiing—we found this petroglyph from Sweden. There's the wolf Fennris, and the swastika. I'm Nordic, and I want to get back to my roots. Instead of believing in some guy walking on water, I want to have my Norse gods. It's just me. I thought about these designs for many years."

TATTOOED PEOPLE:
RICHARD LLOYD-MULLEN

"I've been a fan of *The Lord of the Rings* for 30 years, and I think it's great art. I really love the books and the whole idea of fantasy adventure."

gods for protection, and sailors to this day carry images of mythical creatures that link them to the lore, and lure, of the sea.

In other words, for as long as we've believed, we've tattooed. For as long as we've told stories and invented mythologies, we've converted them into ink. And for as long as we've wanted to explain our beliefs to ourselves and others we've preached, talked, fought, traveled, written, sung, and worn tattoos.

There's no single reason to get a mythical or spiritual tattoo, but if you do choose one you'll find yourself a member of a very old, very diverse church.

GETTING YOUR TATTOO

If you're preparing to get your first tattoo, it's a good idea to know what's going to happen, and how it all works.

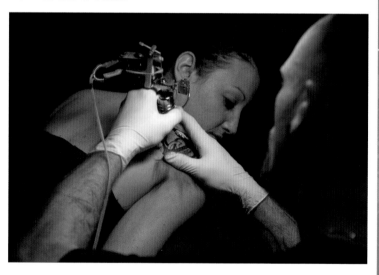

Knowing what to expect goes a long way in helping you relax and begin to enjoy the experience.

DO YOUR RESEARCH

Finding your tattoo artist and studio can be an enjoyable part of the tattoo experience, and it's not something you should rush through. There are plenty of helpful magazines (such as *Skin & Ink*, *Skin Deep*, and *Total Tattoo*) and online communities out there to help you find out more about artists and studios. There's a lot to be said for word of mouth, too, and you'll be surprised how pleased people are to be asked about their tattoos and where they got them; it's pretty flattering. If you see some art you like, consider talking to the wearer about it—you could save yourself lots of time.

tattoo conventions

Visiting a tattoo convention is a great way of seeing lots of artists in one go, checking out the latest talent, and even getting tattooed. As international artists work the convention circuit, it's also a chance to get inked by well-known tattooists who you would otherwise have to hop on a flight to meet. Conventions are heavily promoted online and in magazines, and provide a unique opportunity to congregate with the rest of the tattoo faithful.

What to look for in an artist

Take your time when looking for an artist to mark your skin. Once you have researched the design you want, look around your local studios to see if any of the artists specialize in that kind of work. If they don't, consider looking farther afield, since a great tattoo is worth traveling for.

When you've found a potential artist, look closely at their work and their style of tattooing. Any decent artist will have a portfolio of actual tattoos, not just drawings, for you to look at. Assess the portfolio carefully; you're entrusting your

Always insist that you see your tattooist remove a new needle and tube setup from sealed packaging immediately prior to your tattoo.

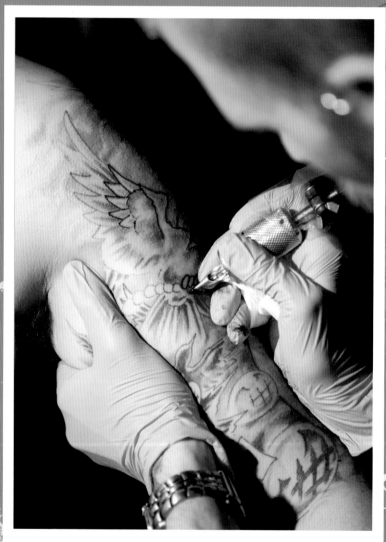

Go to a reputable tattoo studio—don't be afraid of doing your research and taking your time.

FOUR NOBLE TATTOO TRUTHS

For an enlightened tattoo experience:

- Eat beforehand. You'll need the energy and blood sugar.
- Communicate with the artist. If you are feeling ill or in pain ask for a break; no one likes clients passing out.
- Wear the right clothes. Tight jeans on new tattoos are not good. Keep it loose and comfortable.
- Listen to the aftercare instructions. They help.

IN THE STUDIO

All tattoo studios are definitely not the same, so when you're checking out an artist be sure to check out their place of work too.

What should you look for? Reputation is a good place to start. Is the studio well regarded, and has it won any awards? You could also see if it specializes in areas such as spiritual tattooing—as some studios do—so you know you're in the right company.

Once you're in the studio, abandon your higher instincts and trust your gut; it can be a better judge of character than your brain on its best day. Does it feel like the kind of place you want to spend time? Are you comfortable being there, and are the artists and front-of-house staff friendly? It all counts.

Now the big question, is it clean? Not just a bit tidy, but hospital clean, surgically clean. It should be, and if it isn't, move onto the next place. You should expect to see the relevant hygiene certificates, sterilizing equipment, disposal bins for surgical waste (i.e. needles), and gloves on working artists; all things that are far more important than the photos on the walls or the neon sign out front.

bare skin to this person. If you like what you see, try to meet the artist if at all possible to discuss what you want. Personality is surprisingly important, since you'll be spending a fair amount of time with this person while they work. If their laugh makes you want to jam pins in your eyes, you won't enjoy the tattoo experience (and neither will they).

Finally, and most importantly, go to a pro. There's some astonishing talent out there, enough to ensure that no one should ever need to get a bad tattoo from some guy in a shed. You owe it to yourself, and your skin. The more that people refuse to go to disreputable artists (known as "scratchers" in the industry), the sooner they'll disappear from the tattoo world.

THE TATTOOING PROCESS

Many, many technical guides and indepth explanations of the actual

SEVEN DEADLY TATTOO SINS

Make sure that you, or your artist/studio don't succumb to the following:

- Lack of hygiene in the studio. If it's not pure, tell them to go to hell.
- Not opening brand-new needles in front of you and having no visible autoclave (for sterilizing equipment) and hygiene certificate.
- Being drunk/hungover/chemically enhanced. It's not healthy and you might bleed more.
- Talking too much or fidgeting. Let the artist concentrate.
- Swimming and sunbathing with new tattoos; it wrecks them.
- Going for cheapness over quality. You get what you pay for, so spend wisely and buy quality.
- Picking the scab, no matter how much it itches, since you risk pulling the ink out.

nitty-gritty of getting inked exist out there, so this is a very brief overview. Once you have your design, your artist will lay out a stencil on your skin (some may draw it freehand in marker pen). They'll prepare their tools, then begin by outlining the tattoo—generally, this is the bit most people find painful. Next they'll fill in the image, adding color if required as well as shading, all the while wiping off excess ink and blood. Finally, they'll clean everything off, wrap the new tattoo in plastic wrap, and send you on your way—probably with a fairly sizeable rush as your body sloshes adrenaline around and asks "What just happened?" Sounds simple, doesn't it? Well, physical discomfort aside, the actual "sitting and getting a tattoo" bit can be easy for the wearer, if they are well prepared. It's almost the easiest part of the process—hold still and wait to look different!

Whatever method they choose, the artist should put you at ease and explain the process throughout.

LOCATION, LOCATION, LOCATION

Where you get your spiritual inkwork can be as significant as the design itself. Many cultures are quite specific about the location of religious tattoos, because the site of the ink can increase its potency. For example, Thai tattoos are placed as close to the head as possible, since this is believed to be the spiritual center of the body. The heart is seen as the site of purity for other faiths, Christianity included, so some might choose to wear their art over it to show their devotion and sincerity.

With traditional tribal tattoos the location is also important: Maori *ta moko* are designed to correspond to the wearer's body and musculature, and facial *moko* deliberately accentuate the features to give added expression to the face. Likewise, Samoan *pe'a* have specific locations rooted in tradition. (See pages 202–219 for more information.)

Even if the location of your tattoo has no direct spiritual significance, where you wear it still matters. Will the design be on display, for example, or would you prefer to keep it covered? Or perhaps a location that serves both purposes—such as the upper arms, which can be covered or uncovered at will—would suit your needs best?

And, of course, different places involve different levels of pain. It varies, but in general soft areas like the upper arms and calves are relatively pain-free; the shins, wrists, ribs, and anywhere bony are rather less forgiving. Pain may be part of the process and even a cathartic experience for some, depending on why they're getting inked, but forewarned is definitely forearmed.

Finally, bigger is better in tattoo land, and most artists will recommend going as large as you can, to create a better, more balanced piece that will be more durable—fidgety little images will blur over time more noticeably than larger ones. It's all worth meditating on before taking the plunge.

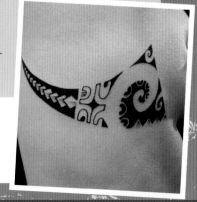

You can afford to be creative with the placement of your tattoos. This delicate tribal design is has been inked just underneath where a underwear strap would curve around the body.

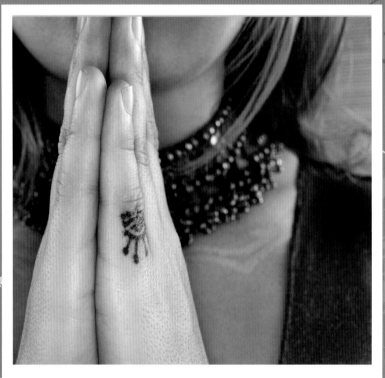

Tattoos on the hand are particulary susceptible to knocks so keep them covered while healing.

KEEPING THE FAITH: AFTERCARE

Once you've gone to the time and trouble of getting a mythical or spiritual tattoo, it's down to you to look after it. Listen carefully to the aftercare instructions your tattooist gives you and follow them to the letter, since this is the best way of guaranteeing a healthy, healed tattoo.

When it's healed, a few devotions will keep your ink on the straight and narrow: keep it moisturized; don't expose it to too much direct sunlight, which will cause the ink to fade; and expect to have it touched up over the years— a little refreshment from some new ink is no sin. But most importantly: enjoy it!

tattoo tools

The electric tattoo machine has been in use (in slightly evolving forms) since Samuel O'Reilly patented it in 1891, and the basic premise hasn't changed a great deal. An electromagnet causes a needle, or group of needles, to vibrate up and down many hundreds of times per second. These needles are dipped in specialist tattoo ink, which they insert between the epidermal and dermal layers of the skin, where it will remain permanently. If you've never been near a tattoo studio before, one thing you might not expect is the noise, since tattoo machines buzz, but this doesn't mean explosions are imminent.

Traditional tattoo implements are still used today in some forms of tattooing. Thai tattoos use long bamboo poles with needles strapped to the end, which are poked rapidly in and out of the skin by the artist; it's certainly not pain-free! Sticking with the pain theme, Samoan tattooing uses the *au*, which resembles a rake made of bone, shell, and wood. The artist strikes the head of the tool with a stick or hammer to drive it into the skin; again, this is not a warm and cozy experience, hence the reputation of Samoan tattooing as a grueling rite of passage for those undergoing it.

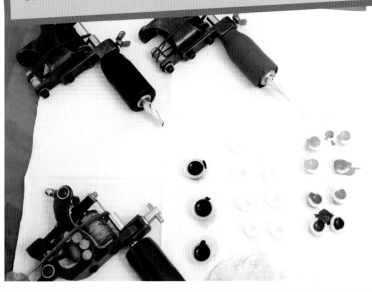

MAKING THE WORD FLESH: PRACTICAL AND ETHICAL CONSIDERATIONS OF SPIRITUAL TATTOOING

In addition to finding the right design, artist, and studio for your new ink, when it comes to mythical and spiritual tattoos there are a few extra practicalities that may need consideration.

FOREIGN ALPHABETS

If you're getting a tattoo in a script other than the one you usually use, make sure you really know what it says. The classic tattoo anecdote is of the hapless wearer of a *kanji* symbol (used to write Japanese) who believes it says "Enlightenment," only to be told one day by a native speaker that it actually means "Torch." Close, but no spiritual cigar. It's a well-worn tale but it exists for a reason: symbols and alphabets can contain myriad complexities that the uninitiated simply can't be expected to understand. If you're choosing a religiously significant phrase and want it inked in Sanskrit, or *kanji*, or hieroglyphics, don't just rely on the first website you find, but do some thorough research, get it checked, and be as sure as you can be. If you're trying to express something personal to you, it's worth getting the words right.

A further issue with foreign script in tattoos is in the execution. Some symbols and alphabets require a great deal of precision on the part of the artist, and the smallest differences can completely alter the meaning of a word or phrase. Again, this is not an area in which to take artistic liberties. Be certain that the symbol is rendered accurately, and think about the basics, however idiotic they may seem. For example, is it the right way around? Has it been flipped accidentally during the stencil process? Are the characters meant to be read left to right (as in English), or right to left (as in Hebrew or Arabic)? God (or whoever) will probably know that

BACK TO LIEF? A NOTE FROM THE AUTHOR

It sounds brain-meltingly obvious, but tattoos involving language need to be spelled accurately. If you're including a quote from a religious text, check it's right. Then double-check. Then get someone else to check. Mistakes do happen: a colleague and I were once just in time to correct the spelling of a tattoo at a convention and prevent the wearer walking around hoping for "riencarnation" for the rest of their lives.

translations of the Bible, which exposed critical errors in previous editions and opened up new theological interpretations of the text. Wars have been fought over this sort of thing (and it's best not to mention the "virgin" versus "young woman" debate when it comes to the "accurate" description of Mary, mother of Jesus). On a less dramatic scale, it's a fact of life that one day your shoddy translation from an online dictionary will be rumbled, so be warned.

it's the thought that counts, but that might not console you if your religious tattoo is backward and upside down.

UNFOUND THROUGH TRANSLATION

Getting something transferred from one language to another carries risks of inaccuracy and mistranslation, particularly if you want to translate a fairly abstract idea into a different language. The subtlety and elegance of the original phrase might well be lost in translation, so take your time and get it right. The religious Reformation in sixteenth-century Europe was fueled in part by new

Get your translation thoroughly checked by a native speaker to avoid any mistakes.

YOUR OWN FAITH

If you're getting a tattoo linked to your own faith (rather than a mythical creature, for example), do you know what your religion's views on tattooing are? There are always disagreements about the Bible's or the Koran's views on inkwork, for example, so be sure you know what you think before you ink.

TRUE ORIGINALS

As well as practical concerns with regards to accuracy, spelling, and grammar, the world of mythical and spiritual tattoos can throw up a few other dilemmas that you might want to reflect on.

One common example is copying someone else's traditional tribal image (or any custom design, in fact). A truly authentic piece of spiritual or tribal art will be designed around the wearer, to fit both body and soul. It will take into account their unique build and musculature, but will also have been created around their beliefs and possibly include an

original prayer, blessing, or mantra. How could an image designed for their frame, and frame of mind, ever fit you properly? Taking inspiration from a piece is one thing, but many artists and wearers consider copying custom work insulting and profoundly disrespectful; definitely worth thinking about before you photocopy that image and head to the studio.

SPIRITUAL AND CULTURAL APPROPRIATION

This leads onto a more philosophical question. Tribal tattoos in particular are sometimes used as examples of cultural appropriation: that of taking a nation's heritage, one different to your own, and simply wearing it like a coat. The theory is that the casual tattoo wearer can't grasp the social and cultural importance of an ancient tradition of body art they have been

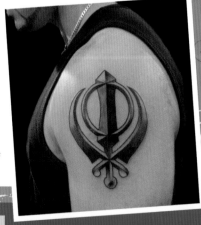

The Khanda is one of the most important symbols in Sikhism, and is rich in religious meaning.

raised entirely independent of; it's like strapping on a curved sword and claiming this makes you a samurai.

The same accusation can be leveled at anyone getting a religious tattoo, tribal or otherwise, if they don't share the faith or culture that their tattoo signposts. Are they simply using faith as a fashion statement and thus debasing it, or should someone be perfectly entitled to choose a religious design just because it appeals to them? Does it need to go any deeper than that?

Of course this is a simplistic version, intended to draw attention to the ongoing debate. Some wearers feel genuine affinity for a particular culture or religion, while others have a more general spirituality and may use different—even conflicting— designs and styles to express it. Equally, some might have no interest at all in faith and spirituality but enjoy the esthetics of traditional Japanese tattooing, or the Gothic spikiness of certain Latin calligraphy based on scriptures. Religion has always sparked disagreements and spiritual tattoos are not exempt from this (although very few crusades have been launched due to tattoos, so far); it's the responsibility of the wearer to know where they stand.

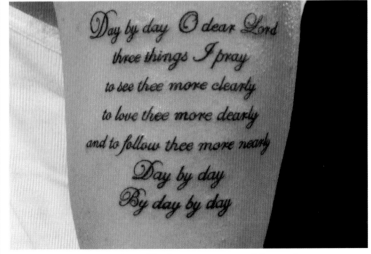

Some let the language speak for itself by choosing a prayer as a delicate script tattoo.

GLOBAL TATTOO MYTHS

In the West, much of the symbolism of a tattoo is down to the design the wearer chooses. However, in other parts of the world just as much significance is placed on the process of getting tattooed—and the designs are believed to have a function far beyond personal devotion or taste.

RITES AND RITUALS

Tribal tattooing is surrounded by very particular rites and rituals, which vary from the tools used, to the time taken, to what the final tattoos represent for those receiving them. To the Dayak people of Borneo, for example, a tattoo can show a warrior's prowess as a headhunter and will light up after death, guiding the wearer's spirit through the murk of the underworld to the village of their ancestors, and allowing them passage past any obstacles they meet on the way. Similarly, the scarification practices of the Betamaribe people in Benin are vital if the wearer is to be considered both part of the tribe, and even human; the tattoos are carried out on children and if they're not present at death, a person won't be buried in their village's cemetery.

A tattoo studio in Borneo, Malaysia, uses the traditional Iban tribe tattoo method—by hand.

IDENTITY

Identity is a large part of the ritual symbolism surrounding tribal tattooing. To the Maori, a tattoo shows lineage, rank, and social status; to Kaningara men in Papua New Guinea the process is a rite of passage lasting several months and culminating in a bloody scarification session that sees their bodies cut and etched to reflect the skin of the crocodile, giving the men the crocodile spirit themselves.

Likewise in Samoa, Tonga, Tahiti, and throughout Polynesia, a traditional tattoo was (and remains) governed by rules of position, design, and execution, and those performing the tattoos were often held in high regard within their society, while those receiving them were expected to bear the pain stoically. This would prove their courage and usher them into the world of adulthood. As tattoo adventurer and anthropologist Lars Krutak puts it in *Body Art 3* (Dennis Publishing, 2009) "for most tribal groups, tattoo rituals represent a rite of passage marking the physical and psychological movement from one stage of life to the next." The tattoos would also act as a spiritual anchor, rooting the wearer within their culture and linking them back to their ancestors, as well as including designs of religious importance.

Wai Kru Day at a Buddhist temple in Thailand where monks tattoo devotees.

BLESSINGS

On a much more overtly spiritual/mystical level, traditional Thai tattooing requires monks, prayers, chanting, and a diamond-sharp meditative mind for the designs to be properly realized and charged with magical properties. The act of tattooing, as much as the design, is the source of the spiritual/magical power: some wearers return regularly to get their spiritual tank topped up by having a monk bless their inkwork. This idea, that a spiritual exchange is necessary as well as the creation of a physical tattoo, is at the heart of mythical or religious body art in many parts of the world. (So in theory, there's nothing to stop you asking the vicar to bless your tattoo.)

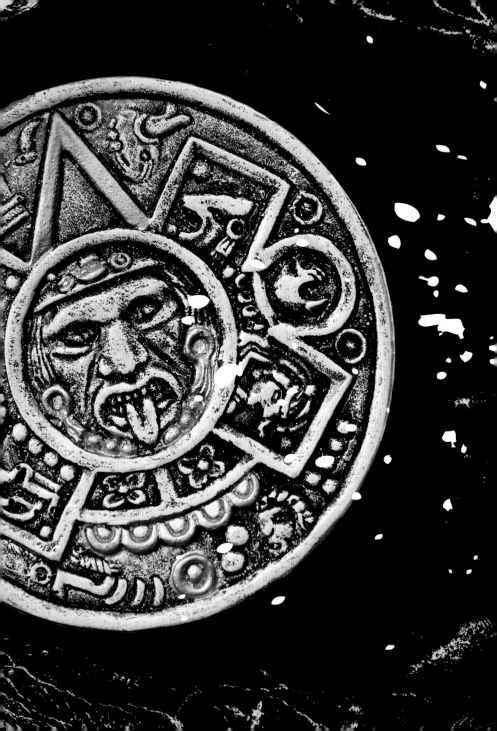

SCRIPTS AND SYMBOLS

In matters of faith and spirituality, a symbol can sometimes speak far more eloquently than anything else. A cross is a clear sign of Christianity, for example, but also hints at sacrifice, suffering, and redemption; likewise Ouroboros is the simple circled snake that contains infinity in its coils. Symbols are versatile tattoo designs, enabling artists and wearers to create their own variations and signal their beliefs clearly.

Scripts are popular for all kinds of reasons. They can literally spell out your beliefs, for one thing; but they can also be mysterious, exotic, decorative, or puzzling, depending on the style, language, and message you choose. They're particularly apt for mythical and spiritual tattooing as they allow wearers to include quotes from stories, scriptures, or other holy texts—you can remind yourself of commandments to obey, or even sins to collect.

CROSSES

The cross is probably one of the most instantly recognizable religious or spiritual symbols in human history. As talismans, tokens of faith, or anchors grounding us in the fundamental elements that make up the universe, crosses have been important tattoos for thousands of years.

The cross symbol has had a relevance for people of various cultures throughout the world and at different points in time, and can carry a huge range of meanings. The Latin cross—with a longer descending arm—as used by the Christian faith, is only one example.

The earliest physical evidence of tattooing that has been found is of a cross. It is emblazoned on the back of the right knee of Ötzi the Iceman, a Copper-Age man alive around 3300 BCE, and found preserved in glacial ice. Although the specific meaning of his tattoo will never be known, it shows that the cross has been valued as a symbol for millennia.

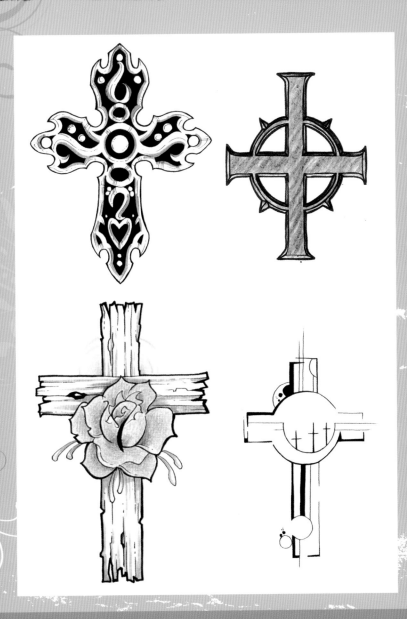

STYLES AND SYMBOLS

A cross can't exist without two distinct lines joining together, and as such is a symbol of unity and harmony between different concepts, such as the four elements of earth, air, water, and fire, or the four compass points. The intersecting lines can also stand for the heavens and the Earth, the sun and stars, and even immortality. A cross tattoo with arms of equal length, sometimes called a "Greek cross," can represent the human form, or a pure mathematical idea.

A cross with a loop at the top becomes the Egyptian *ankh* symbol, representing rebirth, a meaning later adapted by the Christian faith to signify eternal life through faith in Jesus Christ. This cross is also the sign of Venus in astrology.

CHRISTIAN SYMBOLISM

Ultimately it is the Christian symbolism for which crosses are probably best known, standing for the death of Christ on the cross to atone for mankind's sins, and therefore potent symbols of sacrifice, redemption, and love. The simple Latin cross is staggeringly popular as a tattoo and can be depicted in many ways, from plain and austere to highly decorative, allowing Christians to display their faith but also to remind themselves of their beliefs on a daily basis.

Variations on the Latin cross carry different meanings for Christians, too. Three lines at the base might represent the holy trinity or the hill at Golgotha where Christ was crucified; on top of the cross they might represent the Pope, God's representative on Earth in the Catholic faith.

THE CELTIC CROSS

Similar to the Christian cross is the Celtic cross, a Latin cross with a circle behind it, which is thought to be a fusion of Celtic, Christian, and even Norse influences. Often carrying intricate knotwork believed to represent eternity and the cycle of existence, a Celtic cross can be a Christian symbol, a reminder of Celtic or Scandinavian roots, or perhaps the union of heaven and earth within the circle—and eternal life as a result.

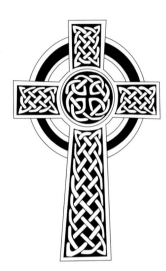

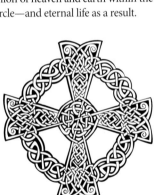

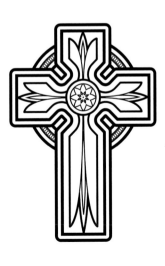

RUΠES

The runic alphabet maintains an air of mystery, perhaps because the precise origins and meanings of the characters remain unknown.

An individual rune might be interpreted in several different ways, making runes intriguing choices for tattoo designs. The *algiz* rune is variously interpreted as meaning "elk" and "protection," for example, so it's worth taking the time to investigate some of the potentially conflicting meanings of your preferred symbol, just in case.

RUΠIC HISTORY

Letters known as "runes" formed an ancient alphabet used by various Germanic languages before the Latin alphabet was finally adopted. The earliest inscriptions using runes date from the first or second centuries CE, and runic alphabets went through several transformations before gradually disappearing (with only a few exceptions) by around the twelfth century CE. In their time they appeared in manuscripts, were carved on stones and buildings, and decorated the coins and weapons of the Vikings. Norse legends describe them as gifts from the god Odin, so it's hardly surprising that they carry a certain mystical aura.

Algiz:
Protection

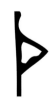

Burisaz:
Thor

The Viking runic alphabet is known as the *futhark*, and when we talk of runes today we are generally refering to the "younger" *futhark* alphabet used in Viking-age Scandinavia around the ninth to eleventh centuries CE, which consists of 16 runes. The original "elder" *futhark* contained 24 runes.

MODERN USAGE

Runes have been adopted by various modern movements, and are often thought to have magical properties of divination. Their original meanings and uses were probably more complex than we'll ever know, and there's little direct historical evidence to support claims of their magical abilities, however, runes undoubtedly have a curious mythical weight to them that makes them popular choices for tattoos—with Angelina Jolie, for example, who sports rune inkwork. Just remember not to believe everything you read about them.

Jera: Year/Harvest

Wungo: Joy

Fehu: Cattle/Wealth

Sonilo: Sun

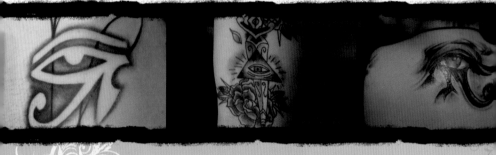

HİEROGLYPHİCS

Hieroglyphics, the characters that form the pictorial writing system of the ancient Egyptians, have baffled and fascinated people for centuries. Until the turn of the nineteenth century it was unclear whether they were a form of alphabet or powerful mystical symbols.

The curious images of eyes, falcons, and dog-headed figures adorned the tombs of pharaohs and seemed to be carved into the very heart of Egyptian culture—some statues from the period suggest that the ancient Egyptians themselves may have been inked with hieroglyphics. Yet their meaning remained unknown, so it's hardly surprising that they retain a mysterious quality even today.

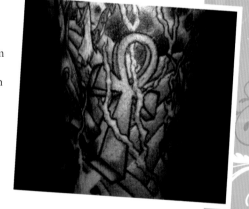

The ankh, right, is a hybrid of two universal symbols, and there is differing opinion about the meaning it holds.

DECODING

Everything changed with the discovery of the Rosetta stone in 1799, which provided the key for decoding the hieroglyphics. The stone showed a hieroglyphic text translated into both Greek and an Egyptian language, paving the way for a better understanding of a writing style that had vanished by the fourth century BCE.

EYE OF HORUS

A sacred symbol of protection, Horus was the far-sighted sky god with a bird of prey's head. This hieroglyph also appears on tombs to offer protection in the afterlife.

ANKH

A mystical symbol combining the cross and the circle, suggestive of the sun, heaven and earth, rebirth, and perhaps male and female—from the gods Osiris and Isis.

Two options for the letter "o" in hieroglyphic script.

CHOICES

As tattoos, hieroglyphics may reflect an interest in or affinity with all things Egyptian. Their distinctive esthetic might appeal to the wearer's tastes, or suggest a deeper connection with ancient Egyptian preoccupations with the sun, death, cycles of rebirth, and a complex mythology of Gods and the afterlife. Meaningful scripts might be translated into hieroglyphics, or the wearer could choose a specific hieroglyph that resonates with them.

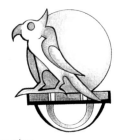

SHEN-RING

A sign for infinity, protection from chaos, and the rising sun over the horizon, the shen-ring was used in carvings to encircle the names of pharaohs, shielding them from harm.

İNFİNİTY AND Pİ

The infinity loop and pi symbols are both representative of a neverending cycle.

İNFİNİTY LOOP

Knock the number "8" onto its side and you've suddenly got a very complex symbol—the infinity loop. In mathematical terms it's the number too large to be written down. Philosophically it's the continual cycle of existence, which can give it religious overtones of immortality or resurrection. It can also remind us of our place in an infinite universe, which can be either comforting or terrifying, depending on your view.

Pİ

Like infinity itself, pi is the number that goes on and on, beginning 3.14159265 and continuing until even the most powerful computer gives up. It's a distinctive Greek symbol that defines the ratio of a circle's circumference to its diameter.

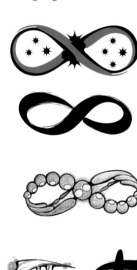

CIRCLES AND OUROBOROS

Humans love a circle. We see the world through the circles of our eyes, and arguably our most important creation, the wheel, takes the form of the simple circle. Indeed, for some schools of Zen Buddhism, the circle is the ultimate expression of the universe.

CIRCULAR SIGNIFICANCE

In terms of tattoos, circles can signify eternity and order, and might represent a barrier that keeps chaos out and good protected inside. They mark out a sacred space, remind us of clocks and halos, or simply represent a soothing, geometric perfection.

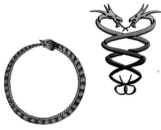

Following on from this, Ouroboros is the "tail devourer," the circular snake eating itself. It looks great as a tattoo armband, emphasizing musculature, but also carries the meanings of the circle: an eternal process of creation and destruction reflecting life, the universe, and everything.

OM AND YIN YANG

Eastern symbols have found a home in tattoo art.

OM

Om, the sacred Sanskrit symbol at the heart of the Hindu faith, saturates the religion at every level. In India itself you'll see it everywhere: in roadside shrines and vast temples, or marked on the skin with ink or henna. It's the opening and closing breath of mantras and the sound that brought the universe into being. It's a popular tattoo, reflecting deep spirituality, and might be worn for protection. O*m* is also an important element of other religions, including Buddhism, which places it at the beginning of *"om mani padme hum,"* the sacred heart mantra.

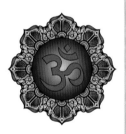

YIN YANG

The concept of yin yang, that opposite forces complement each other and exist within a larger whole, is central to Chinese Taoist philosophy. It is often represented by the *taijitu* symbol, which shows the opposing forces swirling within the whole, with elements of one always appearing in the other. Yin and yang don't correspond to good and evil; instead the concept is more about the notion of achieving harmony between separate energies.

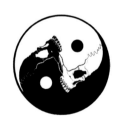

THE EVİL EYE

Many cultures throughout history have a version of the evil-eye superstition. It can be seen as the result of an envious gaze from a jealous person, a kind of magical curse, or perhaps an injury accidentally passed on by someone afflicted with an evil eye.

To wear a tattoo of the evil eye itself might suggest ill will or envy toward others, but might also reflect the "eye for an eye" approach of Tibetan *dzi* beads, which feature an eye design to combat the assault. In fact, many different cultures have created their own talismans, often featuring an eye design. For example, the Mediterranean *nazar*, especially popular in Turkey, is a bright blue-and-white eye intended to ward off the gaze. Other symbols include the Hand of Miriam or Fatima in Jewish and Muslim cultures respectively, and of course the sign of the cross.

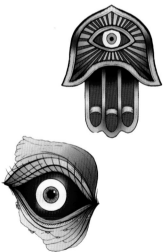

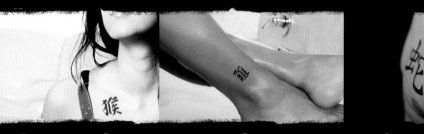

CHINESE ZODIAC

The 12 animals of the Chinese zodiac relate to a 12-yearly cycle, with each animal symbolizing the characteristics of people born in that year.

Unlike the Greek zodiac, the animals are not based on constellations. One origin myth explains that the animals raced across a river to decide the order of the zodiac, watched by the Jade Emperor. The cunning rat rode across on the back of the kindly ox, leaping off at the riverbank and therefore coming first. He also neglected to tell the cat about the race, hence the cat's absence from the zodiac and his eternal enmity toward his former rodent friend.

Rat	Ox	Tiger	Rabbit
Years: 1912, 1924, 1936, 1948, 1960, 1972, 1984, 1996, 2008	Years: 1913, 1925, 1937, 1949, 1961, 1973, 1985, 1997, 2009	Years: 1914, 1926, 1938, 1950, 1962, 1974, 1986, 1998, 2010	Years: 1915, 1927, 1939, 1951, 1963, 1975, 1987, 1999, 2011
Traits: Tenacious, prosperous, scheming	Traits: Dependable, stubborn	Traits: Fortunate, powerful, aggressive	Traits: Kind, lucky, superficial

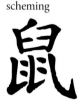
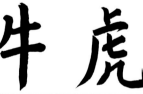

鼠　牛　虎　兔

龍

Dragon
Years: 1916, 1928, 1940, 1952, 1964, 1976, 1988, 2000, 2012
Traits: Strong, noble, arrogant

Snake
Years: 1917, 1929, 1941, 1953, 1965, 1977, 1989, 2001, 2013
Traits: Wise, elegant, vain

馬

Horse
Years: 1918, 1930, 1942, 1954, 1966, 1978, 1990, 2002, 2014
Traits: Confident, inquisitive, fickle

Sheep
Years: 1919, 1931, 1943, 1955, 1967, 1979, 1991, 2003, 2015
Traits: Artistic, peaceful, weak-willed

猴

Monkey
Years: 1920, 1932, 1944, 1956, 1968, 1980, 1992, 2004, 2016
Traits: Inventive, quick-witted, manipulative

Rooster
Years: 1921, 1933, 1945, 1957, 1969, 1981, 1993, 2005, 2017
Traits: Loyal, practical, egotistical

Dog
Years: 1922, 1934, 1946, 1958, 1970, 1982, 1994, 2006, 2018
Traits: Honest, affectionate, lazy

豬

Pig
Years: 1923, 1935, 1947, 1959, 1971, 1983, 1995, 2007, 2019
Traits: Patient, sincere, fatalistic

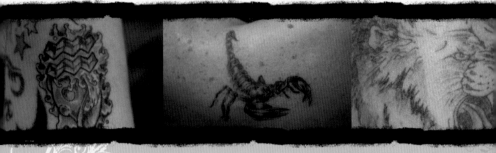

THE GREEK ZODIAC

Like the Chinese zodiac, these symbols are extremely popular tattoos. People choose them to show a belief in astrology, to note the period of their birth, and to acknowledge that they share some of the traits associated with their star sign.

Curiously, although the system was principally defined by the Greeks, the signs themselves are best known by their Latin names.

ARIES
THE RAM
Mar. 21–Apr. 20
Traits: Generous, loyal, impatient

TAURUS
THE BULL
Apr. 21–May 20
Traits: Loyal, strong, jealous

GEMINI
THE TWINS
May 21–June 21
Traits: Calm, charming, two-faced

CANCER
THE CRAB
June 22–July 22
Traits: Sensitive, shy, brooding

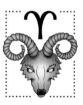
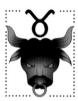

 LEO THE LION
July 23–Aug 22
Traits: Proud,
inspirational,
loud

 SAGITTARIUS THE CENTAUR
Nov. 22–Dec. 21
Traits: Friendly,
ethical, proud

 VIRGO THE VIRGIN
Aug. 23–Sept. 22
Traits: Picky,
aloof, ultimately
loyal

 CAPRICORN THE SEA GOAT
Dec. 22–Jan. 19
Traits: Humorous,
thrifty, disciplined

 LIBRA THE SCALES
Sept. 23–Oct. 22
Traits: Just,
in need of
approval,
facetious

 AQUARIUS THE WATER CARRIER
Jan. 20–Feb.19
Traits: Quirky,
idealistic, good
teachers

 SCORPIO THE SCORPION
Oct. 23–Nov. 21
Character
traits: Intuitive,
emotional,
possessive

PISCES THE FISH
Feb. 20–Mar. 20
Character traits:
Empathetic,
romantic,
indecisive

LATIN TEXT

What did the Romans ever do for us? They gave us Latin, the antique language of scholars, the Church, and the legal system that's still very much alive today. Many European languages have their roots in Latin, and it can be seen in the mottoes of societies, branches of the armed forces, and many other institutions.

TATTOO TEXT OF CHOICE

So what makes it such a popular language for spiritual tattoos? For a start, organized religion, and in particular the Catholic Church, has relied on Latin for centuries, linking the language to the Christian faith and making Latin quotes from the scriptures a popular tattoo choice for many.

A further reason might be purely visual. Latin was previously used in medieval illuminated documents, painstakingly inked by monks to create documents that were minor works of art in their own right. Latin can be written in any typeface or style, of course, but in tattoo art it's still regularly crafted in a similar calligraphic fashion to those old manuscripts, giving the designs a timeless look that has the weighty, authoritative feel of the old church.

Of course any script in a different language requires translation. Since very few of us actually speak Latin regularly, spiritual tattoos in the language gain just a little more mystery.

ego resurrectio et vita
I am the resurrection and the life

fides, spes, caritas
faith, hope, charity

vive ut vivas
live so that you may live

A tattoo of the latin phrase Per aspera ad astra *which roughly translates as "Through hardship to the stars."*

Ego Alpha et Omega, primus et novissimus principium et finis
I am the Alpha and Omega, the first and the last, the beginning and the end

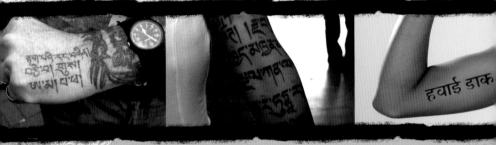

SANSKRIT

Arabic or Persian text tattoos should be given plenty of thought; make sure you choose the words or phrases wisely.

The principle sacred texts of Hinduism, the Vedas (1500 to 600 BCE), are all composed in Sanskrit, as are the great epics *Mahabharata* and *Ramayana*. The *Mahabharata* itself includes the Bhagavad Gita, an essential part of Hindu lore, which Gandhi described as being "engraved on my heart." In addition to Hinduism, the Vedas—and Sanskrit—influenced Buddhism, Jainism, and other Eastern religions.

A Sanskrit tattoo is a deeply spiritual one, particularly if it incorporates *om* (see page 38) or text from any of the ancient texts: the script adds a further layer of meaning to the words themselves, allowing the wearer to display their faith in Eastern religions and philosophies using one of the world's oldest known languages.

काम:
Desire

शुद्ध
Peace

निर्वाण:
Nirvana

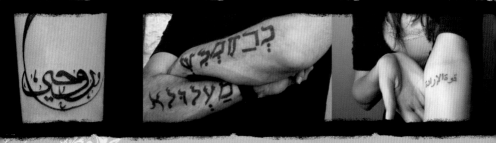

ARABIC AND FARSI

ARABIC

Arabic, the language of the Koran, is a little problematic when it comes to spiritual tattoos. While people do choose to get inked with the graceful, distinctive script, the choice of subject is extremely important. For example, verses from the Koran might not be appropriate, since they are not meant to be taken anywhere impure: hard to achieve when a tattooed body will inevitably use the toilet.

FARSI

A spiritual tattoo using the beautiful "hanging script" of Persia can take advantage of the thousands of years of Persian calligraphy, which has made the written word an art form. Subject matter might be prayers or even Persian poetry, particularly the mystical verses of Rumi, the Sufi poet.

Love حُب

King ملك

Queen ملكة

الف ب پ ت ث ج چ ح خ د

ذ ر ز ژ س ش ص ض ط ظ ع

غ ف ق ک گ ل م ن و ه ی

Farsi alphabet

47

HEBREW

The principle religious works of Judaism, the Tanakh, Torah, and Talmud, are written in Hebrew, a language that can claim to have been in use, unbroken, for many thousands of years. A tattoo in Hebrew, whether the wearer is Jewish or not, will always carry some kind of spiritual resonance because of its close association with these ancient texts and Judaism itself.

RESEARCH REQUIRED

Hebrew tattoos adorn celebrities such as Madonna and the Beckhams, doubtless because of the added gravity they are seen to give phrases such as "I am my beloved's and my beloved is mine," which features in the mutual Beckham inkwork.

Beware, however, since Hebrew is a complex written form with many variations for the same phrase. It's also written right to left, so anyone planning a Hebrew tattoo should consult an expert before going under the needle—proclaiming your faith in Dog would be pretty mortifying, after all.

If I am not myself, who will I be? אם אני לא עצמי, מי אני אהיה

Fortune favors the brave מַזָּל וְהַצְלָחָה תומכים אמיץ

ELVİSH

Somewhat younger than Hebrew, Elvish has only been in existence since the 1930s, when J.R.R. Tolkien created it for *The Lord of the Rings*. Although the language shows strong Finnish and Welsh influences, it's entirely Tolkien's creation, and the fact that it exists in tattoo art shows the enduring appeal of his vision, and the esthetic beauty of the script he drew.

ΠΑΤURAL CHOİCE

Elvish tattoos show an appreciation for *The Lord of the Rings*, of course, but also reflect the wider spiritual beliefs of the Elves. This means a powerful connection to nature and a love of the outdoors, as well as a belief in magic and the nobility of the spirit. You won't be alone with an Elvish tattoo: all the actors who formed the Fellowship of the Ring in Peter Jackson's film version have them too.

Love Freedom Power Courage

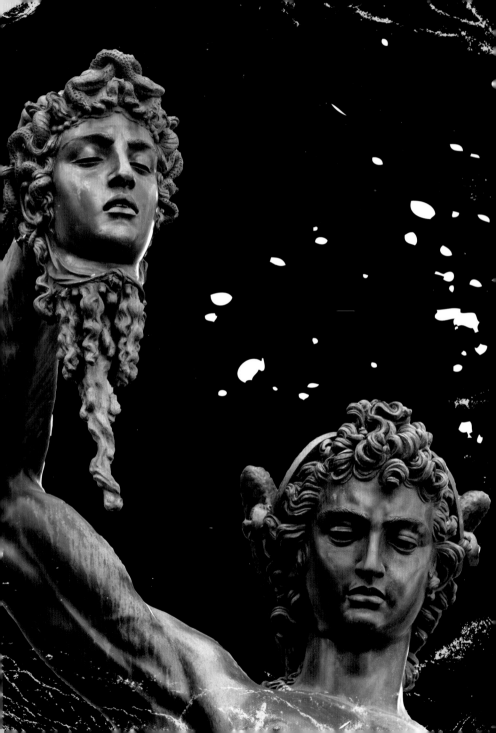

CLASSICAL MYTHOLOGY

Classical mythology, with its cast of gods and monsters, can be a rich source of tattoo ideas. However, there's more to the myths of the ancient world than a cast of grotesques, heroes, and immortals simply leaping from bed to bed or swinging at each other in cataclysmic *Clash of the Titans*-style battles. They can act as morality tales, designs for life, and signposts to the wearer's heritage, however archaic the myths themselves are.

But of course they're also exciting, bloodcurdling, and tragic in equal measure, so for those wanting dramatic images and stories that can also have depth, this is the place to start. Classical mythology covers the world views and beliefs of many ancient civilizations and also includes some of the cornerstones of literature, such as the Homeric epics, so you'll never be short on inspiration.

ARES AND MARS

The ancient Greek and Roman gods of war make for interesting modern-day tattoos.

ARES

Bearing a helmet and spear, and accompanied by a dog and vulture, the Greek god Ares wreaks havoc and bloody mayhem on the battlefield, where he embodies the lust for battle and carnage. Throughout Greek mythology, and in the *Iliad*, Ares is synonymous with violence and often doesn't seem to care which side he battles for, making him a tattoo for those wishing to instill fear in their enemies, or who wish to emphasize the indiscriminate nature of violence.

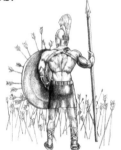

MARS

In his later Roman incarnation, Mars is the revered god of war who became second only to Jupiter in the Romans' affections. Seen as noble and courageous, Mars personifies military valor and in legends is the father of Romulus, the founder of Rome. As a tattoo he lacks the savagery of Ares, and might suit those who wish to emphasize strength and honor in combat.

APHRODITE AND VENUS

Love and its many facets may be depicted in tattoo art by the use of ancient Greek and Roman goddesses.

APHRODITE

When it comes to bed-hopping, you can't beat the Greek gods. Aphrodite, goddess of love, was married to the blacksmith god Hephaestus, but soon took Ares as a lover. Representative of love but also desire, tattoos of Aphrodite can be either romantic or sexual—as the goddess was—and possibly a reminder of the trials of love, since she was partly responsible for the Trojan war after promising Helen of Troy to Paris.

VENUS

Venus, Aphrodite's Roman counterpart, is depicted throughout Renaissance art as the goddess of love, particularly in Botticelli's *The Birth of Venus* (1485). Before that she exists in statues such as the *Venus de Milo* (150 BCE) and was worshiped as the goddess of fertility and love. She embodies these qualities with the added eroticism artists have given her over time.

EROS AND CUPID

The Greek god Eros, and his later Roman equivalent Cupid, are almost identical in their symbolic meanings and share many of the same origin myths. Both cultures feature stories in which the god of love is the son of Aphrodite and Ares/Venus and Mars; both also share tales of the god's love for Psyche, a mortal woman.

IMAGERY

More importantly for tattoo art, both cultures show him as a young boy, or even a baby, with wings, bearing a bow and arrow that he uses to fire love into mortals' lives; sometimes with great results, and sometimes with disastrous consequences—just like the real thing.

As a tattoo, Eros/Cupid symbolizes true love in all its forms—romantic, mischievous, humorous, or serious, and occasionally with a sharp point that comes flying out of nowhere.

POSEIDON AND NEPTUNE

Possible choices for those whose lives revolve around the sea.

POSEIDON

Before there were disaster movies about hapless ocean liners, a Poseidon adventure would have meant an encounter with the Greek god of the sea, who harried Odysseus on his journeys and could raise storms and earthquakes by striking his trident against the ground. Sailors would pray to Poseidon for safe passage across the seas, making him an obvious mythical tattoo choice for today's seafarers.

NEPTUNE

The Roman god Neptune has similar traits, and is also (like Poseidon) the god of horses, sometimes depicted being carried by a horsedrawn chariot. The longstanding "line crossing" naval tradition sees sailors who cross the equator for the first time called to the court of King Neptune, where they're subjected to fraternity-style initiation rites before becoming a "shellback," or "son of Neptune." A tattoo of the god won't get you out of the ceremony, but it remains a logical choice for anyone going to sea.

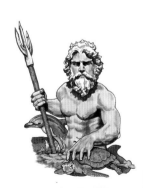

THE MUSES

In ancient Greek mythology the Muses were women who inspired creativity and brought poetry and art into the minds of men.

MUSES AND THEIR EMBLEMS

- Calliope—Muse of epic poetry, whose emblem is a writing tablet.
- Clio—Muse of history, whose emblem is a scroll and books.
- Erato—Muse of lyrical poetry, whose emblem is a cithara (a type of lyre).
- Euterpe—Muse of music, whose emblem is an aulos (an ancient type of flute).
- Melpomene—Muse of tragedy, whose emblem is a tragic mask.
- Terpsichore—Muse of dance, whose emblem is a lyre.
- Thalia—Muse of comedy, whose emblem is a comic mask.
- Urania—Muse of astronomy, whose emblem is a pair of compasses and celestial globe.
- Polyhymnia—Muse of sacred poetry, whose emblem is a pensive expression.

Their role has stayed pretty much the same, although over time they've been refined, named, and given particular creative specialties. Think of a better-looking A-Team, there to help when you've got a creative block.

Invoked in the works of Shakespeare, Milton, Homer, and Virgil, the Muses are great tattoos for creative people who want to keep a source of inspiration to hand at all times.

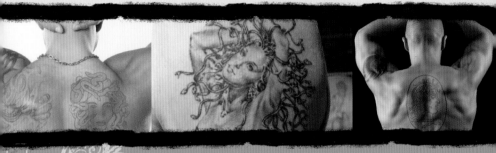

THE FURIES

If the Muses were there to inspire your mind, the Furies (usually a trio of women) existed to drive you out of it.

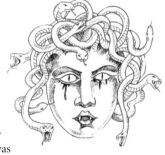

Born either from the blood spilled when Uranus was castrated, or from the pure essence of night itself, the Furies embody wrath and vengeance. Set loose upon murderers and criminals, they could be seen as representing the anger of the dead or as spirits of justice—hence their Greek names *Erinyes* or *Eumenides*, meaning "the angry ones" and "the kindly ones" respectively. Pursuit by the Furies was anything but kind, since they would follow the guilty until they either committed suicide or were driven insane.

Described variously by Virgil, Dante, and others as having serpents for hair, weeping blood, and with bats' wings, the Furies make great horror tattoo subjects, while retaining a close link to ideas of justice and vengeance.

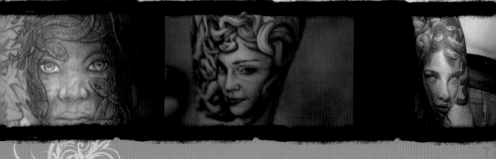

MEDUSA

Medusa is possibly one of the best-known creatures from classical mythology. With her terrible face, head swathed in serpents, and a gaze that can turn onlookers to stone, she's certainly a potent and fearful symbol.

As a tattoo she can simply exist to frighten, her severed head (she was decapitated by Perseus, who used her reflection in a shield to guide his strike) dripping gore while her basilisk stare bores into the viewer.

interpretations

Medusa has had many modern interpretations that could also apply to tattoo art. If you're feeling Freudian, you could say your Medusa tattoo is a talisman suggesting castration and the denial of maternal sexuality (see Freud's essay "Medusa's Head"), while a feminist reading portrays her as the embodiment of female rage. A nihilist sees the ultimate truth in her eyes—that life is meaningless, and we should stop avoiding her gaze and accept death (get turned to stone) instead of fleeing toward hopes and dreams.

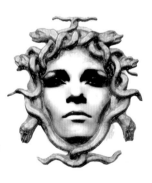

PEGASVS

The winged horse of Greek mythology sprang from the body of Medusa when Perseus removed her head, and subsequently carried the hero on several adventures. He also allowed the warrior Bellerophon to ride him.

THE WINGED HORSE

As a tattoo, Pegasus carries many of the same meanings as a standard horse image: power, grace, nobility, and freedom, as well as intelligence. The addition of wings takes these elements even further and suggests flights of fancy and inspiration, as well as magic and fantastical power.

Pegasus has been adopted as a logo by many organizations, notably the airborne division of the British army, whose logo is Pegasus in full flight carrying Bellerophon, armed with a spear and ready to do battle from the skies.

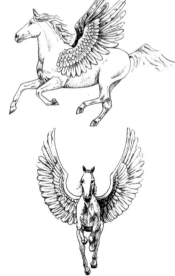

CERBERUS

Cerberus appears in Greek mythology as a three-headed hellhound with a mane of snakes who guards the entrance to the underworld. He prevents the living from entering and the dead from getting out, and is a terrifying creature that might easily suggest fear of death when appearing in a tattoo.

In Dante's *Inferno* (composed in the early fourteenth century) Cerberus is described as a "ruthless and fantastic beast . . . his eyes red, his beard slobbered black . . . he rips the spirits, flays and mangles them." The "spirits" have committed the sin of gluttony and are torn apart by Cerberus for all eternity, so a tattoo of this hound could also be a warning to avoid the deadly sin in all its forms.

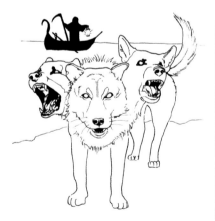

CYCLOPS

The giant Cyclopes were one-eyed monsters who crafted the weapons of the gods. They terrorized Odysseus and later Aeneas in the Odyssey and Aeneid, and could be brutal, jealous, and cruel.

As tattoos they make for fabulous grotesques, both frightening and powerful at the same time. Marilyn Manson has one on his right arm, and he knows a thing or two about the fabulous and the grotesque.

MINOTAUR

With a bull's head and a man's body, the Minotaur is a monster symbolizing the corruption of the human form and the ruling of man by his animal instincts.

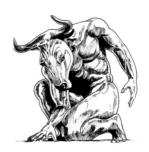

As a tattoo he might simply exist to look scary, but he can also warn the wearer not to be ruled by their bestial nature.

The Minotaur's home was a labyrinth, which can represent the twisting puzzle of life that must be navigated to escape our darker side. A tattoo of the Minotaur in his maze can suggest our troubled subconscious, full of gloomy subterranean passages and prowled by shadowy monsters.

ÍПCA, AZŤEC, AПD MAYA

A tattoo of any of the ancient Mesoamerican deities may hark back to lost civilizations, show a love of Mesoamerican art, or illustrate a belief in the worldview of the ancients, with their close links to the forces of nature, sun, and sky.

These three geographically and culturally different Mesoamerican civilizations, whose combined lands stretched from modern-day Mexico to South America, were conquered by the Spanish conquistadors in the fifteenth and sixteenth centuries. Much of their history was lost or rewritten, but some of their myths and stories have survived. More importantly for tattoo art, so have their sculptures, temples, and artifacts, which provide a fertile hunting-ground for anyone inspired to get an Incan, Aztec, or Mayan tattoo.

ÍПCA

The Incas' principle deities were Inti the sun god and Mama Quilla, the moon goddess. However, they worshiped a huge pantheon of gods and goddesses, all representing different aspects of the natural world. Pachamama, for example, was the earth goddess and responsible for earthquakes, and native Quechua guides still pray to her for safe passage when avalanches rattle in the Peruvian mountains.

Above: An Aztec bird.

AZTEC

The Aztecs are often charged with lopping off people's heads to appease their sun god (and god of war), Huitzilopochtli, although the exact truth of their rituals isn't known. Other important deities included the feathered serpent Quetzalcoatl, a dragonlike god inhabiting the boundaries of the Earth and sky and described as a wind deity and even a god of creation.

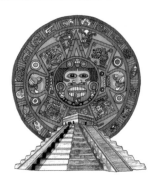

MAYA

Mayan lore is filled with tales of the hero twins Hunahpu and Xbalanque, but also chilling death gods with fleshless heads of bone, and gods of thunder and lightning. Like the Inca deities, many of the Mayan gods embody the violence and unpredictability of nature, perhaps explaining the forces of the Earth to believers.

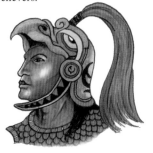

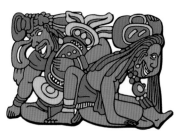

Top: An Aztec calender. Center: A ceremonial Inca mask. Below left: A Mayan warrior. Below right: An Aztec illustration of two people in bright, traditional dress.

ANCIENT EGYPTIAN GODS

Tattoos of hieroglyphics (see page 34), mummies, and pharaohs show a love of all things Egyptian and an attraction to Egyptian esthetics. Getting Egyptian gods and monsters inked does the same thing, but also identifies the wearer with some of the traits of those deities.

AMUN

At various stages in ancient Egyptian history, the god Amun represented the hidden form of the sun, the power of the kings and pharaohs, fertility, and knowledge. He's seen as a man with a curious double-pronged headdress, or sometimes as a ram or man with a ram's head, and at one point was such a popular deity that the prince Tutankhaten changed his name to Tutankhamun, going on to become one of the most celebrated pharaohs.

RA

Another complex god, Ra rose and fell in popularity over the centuries and was even combined with other gods, Amun included, to form new ones such as Amun Ra, the powerful sun god. (Perhaps the priests liked to make sure everyone was paying attention by slightly changing the deities every now and then.) In tattoo art he generally represents the sun and is depicted as either a disk or an eye, bringing light and life to the world.

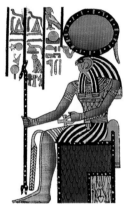

ANUBIS

Jackal-headed Anubis, the god of the dead and the afterlife, is probably one of the most distinctive Egyptian deities. His association with death may come from the fact that jackals were known to scavenge grave sites, so it doesn't take a giant leap to make a jackal the spirit that guards tombs and protects the sleep of the dead.

Anubis was also an important figure in the mummification process—some accounts describe the high priest as wearing an Anubis costume—and is therefore symbolic of the quest for eternal life, which mummification was preparation for. (As a result, throwing this particular dog a bone is probably rather impolite.)

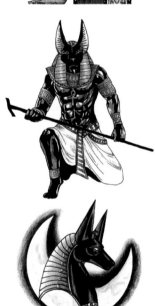

HORUS

Horus was variously seen as the god of the sky, the king, protection, and vengeance. In art he might be seen as a falcon, or as a man with a falcon's head, both linking him to the skies. His eyes are said to represent the sun and the moon—the moon being less bright because he lost one eye in a battle with Set, the god of the desert. (He came off better than Set, though, who lost a testicle, which is why the desert is barren.)

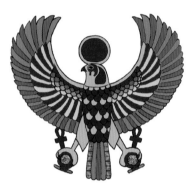

In both Egyptian mythology and as a tattoo, Horus is a god with sharp insight, viewing things from the skies like a bird of prey, and protecting people from dark forces by bringing the light of the sun or the power of kings (he's often closely associated with the pharaohs). The eye of Horus (see page 35) is another powerful protective talisman.

The placement of Horus on the back helps to symbolize the idea of a watchful protector, aiding you when your back is turned.

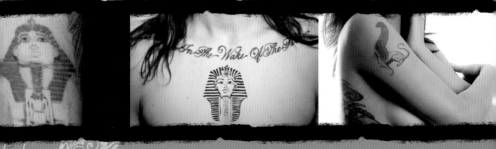

SPHINX

The sphinx is an oddly-built creature, with the body of a lion and the head of a man.

The Egyptian version symbolizes the power of the pharaohs and is a mysterious, enigmatic creature seen in statues and carvings, and who warns of the secrets contained in tombs. As a tattoo, the Egyptian sphinx could easily warn onlookers about the secrets the wearer carries.

Speaking of mysteries, the Greek version of the sphinx poses a riddle and kills those who cannot answer. Should one ask you "What walks on four legs in the morning, two in the afternoon and three in the evening?" answer, man: he crawls as a baby, walks upright in his prime, and with a stick in his twilight "evening" years. With this in mind, a Greek sphinx tattoo might suggest the nature of existence and mortality, which we must all come to terms with.

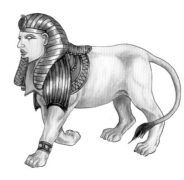

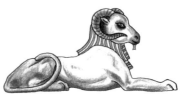

Top: A traditional sphinx with a man's hand.
Below: A criosphinx from Greek mythology with a ram's head.

NORSE MYTHOLOGY

Hammer-wielding gods, snakes that encircle the world, eight-legged horses, and apocalyptic battles... Norse mythology can provide dramatic inspiration for spiritual tattoos.

ODIN

Odin is the chief god of Norse mythology, attracting a lot of symbolic attention and appearing in different guises.

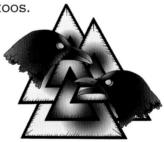

SYMBOLIC FIGURE

Odin may take the form of a one-eyed wanderer, an old man not dissimilar to a wizard, or he might be the conquering god of war, riding his horse into Valhalla (the Norse afterlife) where he will entertain fallen warriors until the end of the world.

Accompanied by ravens or valkyries (warrior maidens), he's a significant figure representing war but also creativity, since, according to some legends, Odin brought the runes to mankind (see page 32), and so can

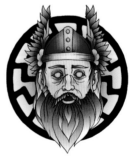

Top: Odin's ravens. Below: Odin.

be seen as a figure of inspiration. As a tattoo he invokes all these varying forms, as well as signifying valor, Nordic ancestry, and the beliefs of those ancient cultures.

THOR

In ancient Norse and Germanic legends, that last right through until the Viking age, Thor is the mighty son of Odin, and a warrior.

The legends surrounding Thor mainly focus on various battles with giants, witches, terrible sea monsters, and serpents. As Thor wields the magical hammer, Mjöllnir, he tends to come out of these contests quite well.

STORMY WEATHER

Thor is also synonymous with storms, thunder, and lightning, and is a symbol of strength, power, and the warrior spirit. In tattoos he appears in full battle gear, perhaps inspiring the wearer to their own feats of strength, or hinting at Germanic heritage and a passion for Norse and Viking mythology.

SCALES AND HOOVES

Norse mythology is home to fabulous and fearsome beasts. Perhaps the most daunting are the Midgard Serpent (also referred to as a dragon), which will kill and be killed by Thor at Ragnarok—the Norse apocalypse—and Nidhogg, another serpent-dragon that gnaws at the tree of life.

Equally fabulous but less bloody, Sleipnir is an eight-legged horse described in various poetic works as Odin's steed and transport to Hel (not Hell), the land of the dead.

Top: Nordic scrollwork of a Midgard Serpent. Below left: Thor's hammer. Below right: Thor.

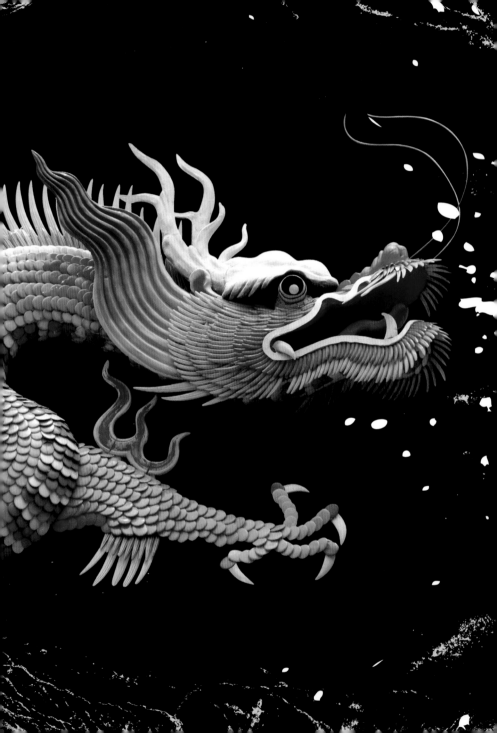

MYTHICAL CREATURES

As if dragons, werewolves, and fairies weren't already lively enough in fiction and folklore, they can take on even more meaning when converted into ink.

On one hand they carry with them their own personal symbolism, born of centuries of fables and legends; on the other they can represent something about the person who chooses them, broadcasting their beliefs to the wider world. You might wear a dragon as a symbol of wisdom and elemental power; or it might be because you love dragons. Either says something about you. Plus, a mythical creature is open to artistic interpretation: no-one will bring their "field guide to fairies" into a studio and explain to the artist where they're doing it wrong (no-one still grounded in this reality, anyway). It's all down to the wearer and tattooist, making these great designs to unleash the imagination on.

DRAGONS

As tattoos, dragons can symbolize many things, depending on where your dragon is from, but however they appear, and whether they're Eastern or Western, dragons and dragon tattoos are powerfully linked to elemental powers, magic, and mystery.

EASTERN DRAGONS

The iconic Eastern representation of dragons, as wingless serpents wreathed in mist, is a key feature in traditional Japanese tattooing. Dragons are sacred spirits of water and air, protectors of the Buddha and the emperor, and bringers of good fortune. They also represent strength, nobility, and imagination, and the balance of power and grace.

An Eastern dragon in tattoo form is a positive creature, worn to protect the wearer and to show an affinity for the spiritual qualities the dragon represents, as well as an appreciation for all things Eastern. In traditional Japanese tattooing the dragon doesn't appear alone, but exists in harmony with other elements in the design, such as water and clouds, symbolizing his elemental aspect and the balance of natural forces. And let's not forget: if the emperors thought dragons were cool, they should be fine for the rest of us mortals.

WESTERN DRAGONS

On the other side of the world dragons are different beasts. They exist in ancient tales, such as the Anglo Saxon epic *Beowulf*, where they represent

sinful levels of pride, avarice, and wrath. In these cases the dragon is a purely destructive force, hoarding his gold and killing indiscriminately until slain by the hero Beowulf, or by the archangel Michael in Christian mythology.

Fire-breathing Western dragons tend to carry associations of power and violence, often symbolizing wrath, vengeance, and cunning, although more recent stories and depictions have cast them in a slightly more friendly light (Puff the Magic Dragon is something else entirely—blame the 1970s). In their tattoo incarnation they might make the wearer look strong or fearsome, remind us of evil forces to be defeated by faith—using an image of St George slaying the dragon, for example—or show a belief in fantasy and magic.

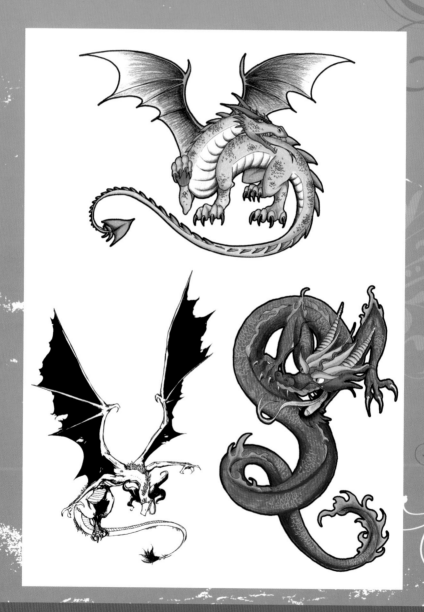

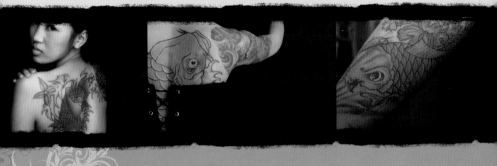

KOi CARP

When is a fish not a fish? When it turns into a dragon, of course. According to ancient Chinese legend the koi (or carp, as we know it in the West) that succeeded in braving the waters of the Yellow River and leaping through the Dragon Gate would be rewarded for its courage and perseverance by being turned into a dragon.

This legend has had the most impact in Japan, where the koi is an integral part of the traditional *horimono* style of tattooing. The fish is usually depicted against water and symbolizes bravery, endurance and having the will to overcome life's obstacles until a dragonlike state of wisdom and power is attained. It's sometimes seen in tattoo art fused with a dragon's head (reflecting the transformation legend) and is far more mythological than your average goldfish, hence its inclusion amongst the other fabulous creatures.

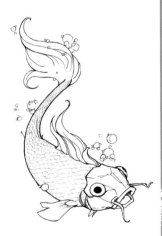

FOO DOGS

Foo dogs were the Buddha's magical companions, and their statues guarded Buddhist temples, and later the emperors' palaces, protecting the truth and driving away evil. Their more modern incarnation (it's only natural for a Buddhist lion to be reincarnated, after all) sees them bringing luck and happiness to homes.

LION AND DOG

First of all, a foo dog isn't really a dog. It's a lion, imagined by ancient Chinese artists who had never seen one before, hence its other title, "Lion of Buddha." Foo dogs in the tattoo realm tend to combine lion and dog attributes, and maintain their Buddhist symbolism. They're often depicted in male–female pairs, with the male resting a paw on a sphere to represent the heavens, and the female holding a cub, representing the Earth. Foo dogs are strong, noble, and loyal, protecting the wearer from evil just like their ancient counterparts did.

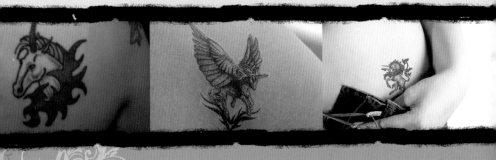

UПICORПS

The unicorn, a white horse with a horn on its forehead, is synonymous with magic and purity.

Medieval legend held that only a virgin could tame a unicorn, hence its associations with virtue and the virginal. Other legends claimed that a unicorn could purify poisoned water, while to the Chinese a unicorn is an auspicious spirit and sign of good luck.

İ BELİEVE
Unicorn tattoos might show a belief in magic, or a wish to be pure and virtuous. They might also act as a good-luck charm or protective spirit, and remind the wearer to tread a blameless, noble path. Equally, they might simply point to a belief in unicorns: just because you can't see one in a zoo, doesn't mean they're not out there somewhere.

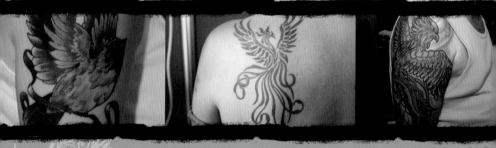

PHOENIX

The undying bird that rises from its own ashes is a popular symbol in tattoo art and has appeared in various folk mythologies throughout history.

Different descriptions of the phoenix are found in the works of the Roman poet Ovid and the French writer and philosopher Voltaire. There are even (disputed) accounts of a phoenix in the Bible, depending on how certain passages are translated. Today the notion of the phoenix as a reborn creature surfaces in the X-Men comics and Harry Potter novels, showing how enduring or immortal the idea is.

REBIRTH

According to almost all the different origin myths from ancient Egypt, Greece, China, and Persia, the phoenix is a brightly colored bird that lives for between 500 and 1,000 years. At the end of its life the phoenix builds a nest or funeral pyre and spontaneously combusts, with a new, young bird being born immediately from the ashes.

Naturally the phoenix has come to be a symbol of new beginnings and eternal life, and because of its association with resurrection it can echo the story of the death and rising of Christ. A phoenix tattoo can suggest any of these interpretations, or point to the endless nature of existence, which is constantly moving from state to state.

CHINESE SYMBOLISM

To the Chinese the phoenix was also closely linked to the empress and is almost as important as the dragon in the pecking order of mythical creatures, so can symbolize femininity and grace, and is a powerful magical totem when worn as a tattoo.

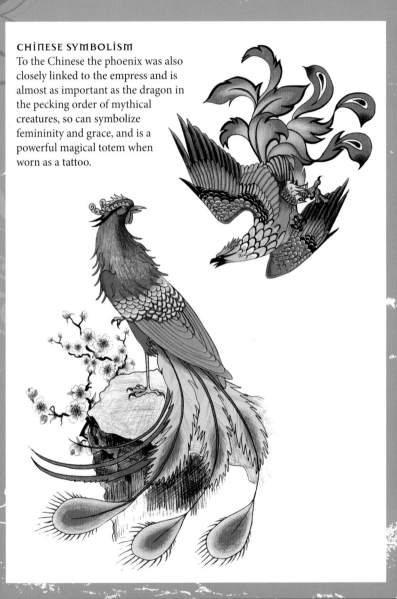

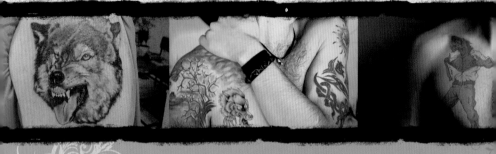

WEREWOLVES

Versions of the werewolf myth have appeared all over the world throughout history, whether it's the lupine allusions in Bram Stoker's novel *Dracula* or werewolf legends in Greek and Roman mythology and literature—the Roman poet Ovid writes of werewolves in the *Metamorphoses*, and Greek myth has Zeus transforming Lycaon into a wolf.

MODERN INCARNATION

To those familiar with the *Twilight* saga, a werewolf is a muscled young chap capable of conveniently turning into a giant wolf—useful when doing battle with vampires and other nasties. The traditional version is rather different, but the *Twilight* incarnation is nonetheless a mythical creature and might well be an attractive tattoo for fans of this more modern interpretation.

BEASTLY ASSOCIATIONS

Symbolically, the werewolf is generally portrayed as a negative force, the result of dark arts and evil, so tends to be a sinister tattoo with frightening aspects. Because the man is lost to the wolf, a werewolf tattoo can tap into fears of our primal nature— the beast within—being unleashed and taking over. Werewolf tattoos remind us of this fear, as well as pointing to an interest in the darker shadows of European folk tales, and the terrors the natural world still held in a time when wolf attacks on humans were not uncommon.

VAMPIRES

Although many of the fears, misconceptions, and superstitions that originally fueled vampire folklore in Eastern Europe have now passed—clusters of deaths from then unidentifiable and mysterious diseases, outbreaks of syphilis and plague, and signs of decomposition being mistaken for eternal life, causing physicians to stake corpses just in case—the image of the vampire is perhaps stronger than ever today.

Myths and legends of blood-drinking demons and deities stretch far back into antiquity. The Romans and Egyptians had them before the "vampire" concept even existed, and the Hindu goddess Kali is sometimes associated with blood drinking. However, the more "traditional" vampire owes much to European literature of the eighteenth and nineteenth centuries, including Polidori's *The Vampyre* and Bram Stoker's *Dracula*. Both tapped into folk tales and embellished them, giving us the black-clad, demonic, undead figures we know and love.

UПDEAD

Vampires can symbolize the curse of an immortal life and the ultimate futility of living forever just to see everything you love die, so they can be tragic creatures. However, they can also be the embodiment of evil, lust, and invasive sexuality (unwanted penetration by fangs, anyone?), representing a fear of the unknown and the terrors of the dark.

A vampire tattoo can be gloomy and tragic or sinister and scary, or it could demonstrate an affinity for the goth/vampire lifestyle and literature. Plus, the latter-day movie vampires tend to be awfully good-looking and brooding, so there's definitely a sexy edge to the modern vamp (with a generous side helping of adolescent angst).

Tattoos don't have to be limited to vampires themselves—puncture wounds are popular too, hinting at vampirism, horror, and being bled dry by external sources.

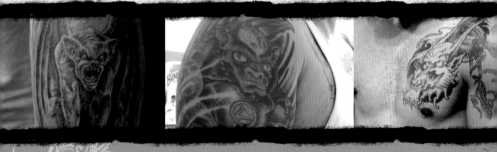

GARGOYLES

Gargoyles are stone carvings that have glared down from churches for centuries. Symbolically they acted as visual representations of the sin and chaos outside the church, ideal for educating illiterate medieval worshipers and warning them of the behavior God frowned upon. Their appearance was also said to frighten away evil.

A gargoyle tattoo might have many of the same functions—it could remind the wearer of the perils of life outside, and the importance of not letting them in (to the heart, mind, and soul). A gargoyle could scare away evil, and because they are usually associated with churches, a gargoyle could even be a reference to faith.

However, there is another idea. Gargoyles were created to embellish gutters, so rather than existing as symbols of piety they might simply be the product of medieval stonemasons showing off their skills (and warped imaginations).

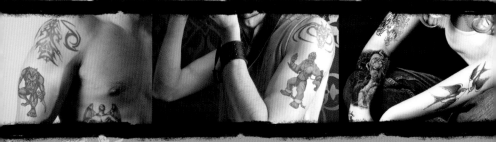

TROLLS

Sharing many traits with gargoyles, troll tattoos may be designed to look gruesome and frightening and to drive away evil. Their origins in Scandinavian folklore mean they have a different look that might be preferable to the Gothic grimace of the gargoyle.

ON A LIGHTER NOTE

Trolls also exist in fantasy literature—notably in Tolkien's *The Hobbit* and Terry Pratchett's Discworld series—so fans of the genre might choose a troll tattoo for that reason, perhaps drawing inspiration from the many illustrations that have accompanied the books. Often described as comically grumpy or slow-witted, trolls are potentially a good source of humor in tattoos as well.

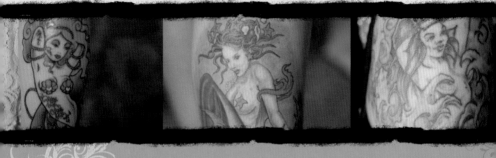

MERMAIDS

Mermaids show up regularly in the old-school style of tattooing, and might be friendly water spirits protecting sailors, or aquatic versions of the sexy pinup girls so beloved in the 1940s and 50s (they could also represent the alluring call of the sea).

On the other hand, mermaids could be seen as sirens: lethal temptresses hell-bent on luring sailors onto the rocks and to their deaths.

SYMBOL OF FEMININITY
Mermaids can also be symbols of empowered femininity, with a magical beauty and grace far removed from the sinister undertones of the sirens. Instead they're positive goddesses symbolizing erotic love and fertility, as much at home on the skin of lovely ladies as they are on salty sea dogs. Disney's Ariel might have nothing to do with erotic love or the doom of sailors, but she remains a popular tattoo. Maybe it's the hair.

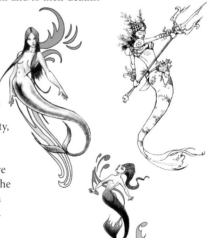

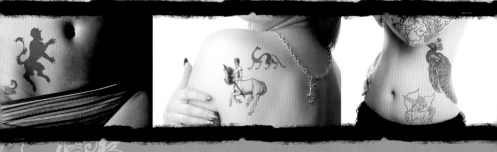

FAUNS AND CENTAURS

These combinations of man and beast carry various symbolic meanings.

FAUNS

Fauns are fantastical creatures with the torso of a man and hind legs of a goat. Fauns were known to the Greeks and Romans as woodland spirits who would help or hinder humans. As tattoos they might simply reflect their literary origins, or act as symbols of the woodlands and the wider outdoors.

CENTAURS

Centaurs are half man, half horse, and appear everywhere, from the Sagittarius zodiac sign to the Chronicles of Narnia novels. In Greek mythology they represent the duality of man's human–beast nature, while modern versions tend to depict wise and noble beings. A centaur tattoo can be all of these things, depending on the wearer.

FAIRIES

Ever-popular as tattoo designs, fairies have been helping us out and wreaking havoc for years. They exist in folklore, contemporary fiction, movies, and cartoons, and are a childhood staple for many of us.

CHILDHOOD

The association of fairies with childhood gives them a playful innocence in some ways, which can come across in tattoos. They can represent a pure belief in magic and a lasting sense of wonder in the face of the natural world, making the trees grow or the flowers bloom, and can be depicted as nurturing spirits. But just as there's more to childhood than sweetness and light, so fairies can also be mischievous, naughty, vicious, and even cruel at times (and yes, that includes Tinkerbell).

SPLIT PERSONALITY

Traditionally fairies were magical creatures seen as agents of fate, capable of bringing about both good and ill. As tattoos they retain this sense of life's unpredictability, but also show a belief in magical influence, or perhaps the hope that guardian spirits have got your back. Some believe that having a good fairy inked onto your body can only improve your chances and bring you luck, while a naughty fairy might hide thumbtacks on the chairs of your enemies (something like that, anyway).

The tricksy personality of fairies also makes them a popular tattoo choice for those who know they can be good and difficult in equal measure, just like the winged folk themselves. But of course there doesn't need to be a vast level of symbolism: fairies are magic, and fun, and that's exactly what some people are looking for.

PİXİES

Often used interchangeably with the word "fairy," a pixie is a mythical creature with origins in Devon and Cornwall, in the Southwest of the United Kingdom.

There, pixies were small magical people, generally friendly, who lived in the wilds of the regions and loved to play. No fixed description exists, so they might be drawn as beautiful small humans, with pointed ears and a love of shiny things and ribbon.

Tattoos of pixies might point to a playful nature, a belief in magical creatures, or even Cornish heritage.

LEPRECHAVNS

Leprechauns are the iconic Irish mascots.

These characters are often described as nimble and pugnacious cobblers with access to a pot of gold. The trouble is, to get at the treasure you must catch them first, and that's easier said than done.

In ink, leprechauns are symbols of Irish heritage, luck, and tenacity, and often appear dressed in green, with red beard and hair, usually with an impish grin.

ELVES

Elves can be contrasting creatures in fiction, folklore, and tattoo art.

You could opt for the fairy-tale version of small, magical people, such as Shakespeare's Puck from *A Midsummer Night's Dream*, or the creatures from Scandinavian, Norse, and Germanic (among others) folklore that populated all levels of the world, in some cases resembling gods, in others dancing in meadows and causing harm and sickness to humans. Alternatively, you could lean toward the ethereal immortal race featured in Tolkien's *The Lord of the Rings*, with their close links to the natural world and a deep, subtle magic.

Depending on your choice, an elf tattoo could point to fairy-tale magic, an affinity for the folk tales of continental Europe, an awareness of dark forces, or a connection to the values embodied by Tolkien's elven race.

Playful tattoo illustrations of (from left to right) a sprite, leprechaun, and an elf.

ANGELS AND DEMONS

The idea of divine or demonic beings influencing the fate of mankind stretches across many faiths, including Christianity, Islam, and Hinduism. According to any of those religions angels and demons are there to protect us, guide us, tempt us or generally get us into trouble, and it's no different in the tattoo world. They can be positive, negative, or ambiguous designs, reflecting our higher selves but also our baser instincts, as well as our relationship with God—however we see him. (Or her.)

Angels and demons, whatever their origin, can decorate your body as if it were a temple and carry a huge amount of religious weight if you want them to. On the other hand, people can (and do) choose angels and demons simply because of the strength of their images. They can be inspiring, funny, frightening or even comforting—and there are plenty to choose from...

ANGELS AND GUARDIAN ANGELS

Angels are divine messengers who appear in many organized religions, notably Christianity, Islam, and Judaism, either acting as the mouthpiece of God or carrying out his will in the world. Usually seen as winged men in this context, angel tattoos show the wearer's faith and act as a constant link between them and their deity, in much the same way as their heavenly counterparts do.

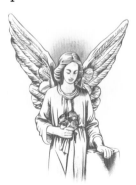 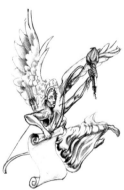

Angels are not the exclusive property of specific faiths, and they're not exclusively male. They can represent a wider sense of spirituality and carry a host of positive connotations, such as love, compassion, faith, and devotion. Guardian angel tattoos might be designed to shield the wearer from harm or prevent them from being led astray. Guardian angel tattoos might also suit those who are protectors themselves, such as police officers or teachers, or anyone who feels responsible for the care of others. Some people draw comfort from the idea that angels are watching over us, and an angel tattoo can represent that idea on the skin.

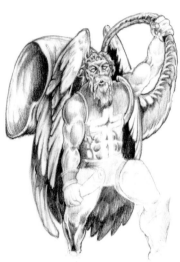

However they appear, angels are ephemeral beings existing on a higher level and embodying spiritual perfection, something that believers of all denominations and creeds might aspire to. Therefore, an angel tattoo can remind us of the constant quest to live well and better ourselves, whatever our faith.

CHERUBS
Often appearing in Renaissance art as plump, childlike figures with tiny wings, cherubs have the same look in the tattoo realm. They're closely associated with cupid and have a similar function as playful messengers of love.

ANGEL OF THE APOCALYPSE

In the Book of Revelation, the Angel of the Apocalypse descends to Earth wreathed in cloud and flame, with a face shining like the sun, to pronounce judgment upon humanity.

Needless to say, this is one of the occasions when an angel doing God's work is not necessarily a kindly, protecting figure. Tattoos of the Angel of the Apocalypse might remind Christians of the end of days, but may also serve as a reminder to all that everything must end.

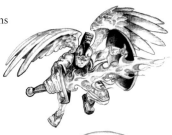

COPTIC TRADITION

The Coptic Church is a Christian Church originating in Egypt, with an ancient tradition of tattoos that signify faith (see page 146). One such tattoo being the Angel of the Apocalypse, seen wielding a sword and carrying a pair of scales. This image was one of many cut into woodblocks and recorded by author John Carswell in *Coptic Tattoo Designs*, published in 1956.

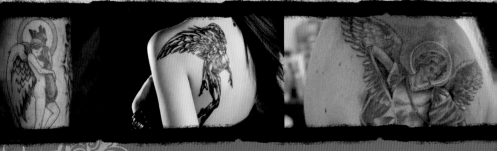

AVENGING ANGEL

Further proof that there's more to angels than giving free hugs to the faithful, the concept of the avenging angel, bringing God's wrath and retribution to wicked people or demons, is a compelling one for tattoo fans.

In a tattoo design an avenging angel might bring fire, the sword, or the scales of judgment, and doesn't have to be an explicitly Christian image: just as guardian angels exist across many faiths, so too do avenging ones. They might serve as protectors, represent the consequences of unjust actions, or remind the wearer to do good.

ANGEL OF DEATH

Death is a complicated character, and one that has been personified in numerous religious texts, and in fiction and folklore across the ages.

As something that comes to all of us, it seems logical to try to give death a face, so that we can look it in the eye in an attempt to accept our mortality—not always successfully, of course.

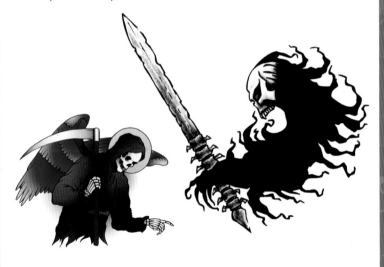

DIFFERENT VIEWS

Tattoos of the angel of death might be influenced by traditional Western views of the Grim Reaper, having him as a winged and hooded figure carrying a scythe and an hourglass. He could equally be a figure on a pale horse, one of the Horsemen of the Apocalypse described in the Bible's Book of Revelation—named as Death, who is followed by Hell. The concept of the angel of death exists in Islamic and Hebrew tradition too, where he is known by many names, including Azrael, a name meaning "whom God helps." According to the Oxford English Reference Dictionary, he is the "angel who severs the soul from the body at death" (ouch) and in one incarnation is described as being made entirely of eyes and tongues; which could provoke interesting reactions from prospective tattoo artists.

HOW YOU LIVE

Wearing an angel of death tattoo isn't necessarily a morbid idea (although it can be, if you're a "paint it black" kind of person). It can actually act as a constant reminder that since death is waiting for us all, it's important to get on with living a full life. Depending on your views of the afterlife and judgment, it can also be a reminder of the world to come, and the consequences of our actions

in this life—you'd better be good, or you'll pay when the angel of death comes calling.

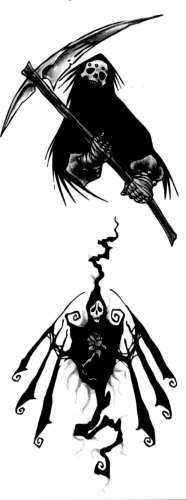

ARCHANGEL MICHAEL

Michael is probably the most immediately recognizable archangel (the elite version of angels in Christianity, Islam, and Judaism). He is the warrior, God's angel-at-arms, who leads his armies against Satan in the Book of Revelation.

Needless to say the archangel is victorious, his triumph representing the vanquishing of evil by good, and the ultimate overcoming of our dark nature by the light of our higher selves.

REPRESENTATIONS

Michael is often seen dressed in armor, wielding a sword, and trampling the Devil underfoot. Sometimes his foe is a serpent, also representing Satan. In tattoo art he appears in a similar guise and represents the triumph of good over evil, light over darkness, and knowledge over ignorance.

Michael isn't just reserved for the religious, although he's obviously a powerful symbolic figure of God's might. He could be a tattoo choice for anyone wishing to show an image of positive forces overcoming negative ones.

ARCHANGEL GABRIEL

Gabriel is an important figure in Christianity and Islam, where he reveals the birth of Jesus to Mary—a role often reprised in children's nativity plays. In Islam he is the messenger through whom God reveals the Koran to Muhammad, as well as foretelling the birth of John the Baptist in the Bible.

Gabriel is often depicted with a horn, which he will blow to bring about the end of time, and is usually described as being a male figure. In tattoos he may represent the word of God, faith in Jesus or Muhammad, or he may embody similar qualities to a more traditional angel; as God's messenger, Gabriel is a significant symbol of spirituality and faith.

LUCIFER AND SATAN

Although they're names for the same entity—the Devil—representations of Lucifer and Satan can be different, because the names refer to different stages of Old Nick's development.

LUCIFER

Lucifer—meaning "light"—was the foremost of God's angels before the fall. When he rebelled against God he was defeated and cast out of heaven, becoming the opposite of everything God and heaven stand for. Instead of light, dark; instead of good, evil.

Tattoos of Lucifer might show him in his fallen state, as a beautiful but battered angel with broken and bloodied wings. He represents a fall from grace and being cast out from the light, making him a sympathetic figure for anyone who feels separate from society. A Lucifer tattoo might also appeal to wearers who appreciate his tragedy, Gothic literature (or the goth lifestyle), or who wish to be reminded of the consequences of pride: a fall.

SATAN

Satan, on the other hand, is a different character. He's the Prince of Darkness, the walking embodiment of evil, the mocking presence who tempts Christ in the wilderness. He might be seen as an immaculately tailored figure with red skin, a forked beard, and horns, or as the nightmarish vision from Dante's *Inferno*, a tormented beast bound in the pit, chewing on sinners and defecating onto Judas Iscariot, the man who condemned Christ.

He can deliberately—and provocatively—represent sin and evil as a tattoo. However, if you don't want to go quite that far, he can also suggest temptation and human fallibility, indicating that you have a dark side and know you're not perfect. Flipping the meaning entirely, Satan might even act as a warning of the perils of sin and temptation. He'll always be popular with music fans, too—after all, he does have the best tunes.

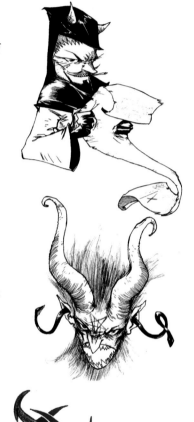

Top: Satan as the Prince of Darkness. Center: Satan in his goat's head form. Below: A tattoo artist's tribal-style representation of Lucifer. The face represents the fallen angel.

DEVİLS

Devil tattoos can refer to the Devil himself (see pages 102–103), but the slightly more cartoonish versions here have more playful connotations.

Like a kind of anti-cherub, these devils represent lust, temptation, and vice, rather than pure evil. They're beloved of bad boys and girls who want to advertise their dark side with pride, and as their alternative name, "hot stuff," implies, they also carry subversive sexual hints, as well as pointing to the temperature if you choose to go back to their place.

This kind of devil can also stand for mischief, making them an ideal choice for merry pranksters who may not take life, or themselves, too seriously. Far from having wicked symbolism, this kind of devil might simply show that the wearer has a talent for naughty behavior— a far cry from evil.

DEVİL GİRLS

Devil girls might be a tongue-in-cheek corruption of the old-school pinup girl, but they can also have deeper connotations of female dominance, lust, and sexual power (which can be a good or bad thing for either sex, so they're pretty multipurpose). A devil girl can be overtly sexual and symbolize temptation, carnal sin, and other perversions of the flesh (if you like), or they can just be a bit cheeky. How far you twist the sin-o-meter dial is entirely up to you—there's a different kind of devil in everyone.

TRADITIONAL AND FICTIONAL DEMONS

The concept of the demon (or daemon) is remarkably pliable, which suits tattooing nicely: a demon can take whatever form the imagination dictates, making it an ideal subject for creative inkwork.

IT'S NOT ALL BAD

Although the word "demon" now tends to have associations with evil and the devil, demons don't have to be malevolent forces. In fact, various cultures have regarded them as guardian spirits, companions, or beings with the will to choose whether to help or hinder (such as the Islamic concept of a *djinni*), just as other faiths see demons as fallen angels.

In art and literature demons have the same ambiguity. Fictional demons move away from classical demonology, which is the study of demons as they appear in theology and religious

texts, so are free to prowl the caverns of our minds in any shape we can conjure. Tolkien's demons are creatures of darkness from the deep places of the world, for example, while they appear as allegorical representations of the soul in Phillip Pullman's His Dark Materials trilogy.

in tattoo terms

In tattoo art demons can manifest as positive forces, or they can appear as terrifying supernatural beings up to their necks in wickedness. Demons peer through torn flesh, cling to backs, perch on shoulders, and scale arms. They might exist to frighten, to show the dark mind of the wearer, or to act as a guardian; or they might pay homage to a specific demon from

art, religion, or even contemporary culture—the Hellboy character from graphic novels is a demon, and so, in some incarnations, is Batman. When it comes to tattoos, being surrounded on all sides by demons isn't necessarily a bad thing.

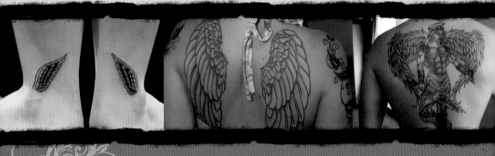

WİNGS, HORNS, HALOS, AND MORE

Angels and demons don't need to appear in person in tattoos to suggest their presence. Any self-respecting supernatural entity knows how important it is to accessorize, so there are many tools and symbols that represent them.

WİNGS

Wings are popular designs and can take many forms. They might appear as feathered angel wings, suggesting all the positive attributes of an angel and linking the wearer to the ability to fly toward heaven. Alternatively, they might be the leathery bat wings of a demon (or the Devil), or be the broken pinions of the fallen angel, both of which suggest temptation, sin, and a fall from grace.

HORNS AND HALOS

Horns and halos are easily identified with demons and angels respectively,

and may suggest a religious or spiritual sentiment. They can also be worn with a sense of humor, suggesting that a person is a little devil or angel (or at least they try to be). Worn in combination, they might point to our conflicting capacities for good and evil, or that we all have good and bad days.

TRIDENT

A trident is often associated with Satan, so left on its own propped up against an arm it suggests he's been around—and might well be back. This could acknowledge that temptation is everywhere and remind the wearer to be vigilant, or it could be a sign that the Devil has made himself at home.

HARP

A harp is often linked to angels, so as well as pointing to a love of music, it could signify belief in angels and, similar to the trident, suggest that one isn't far away from the wearer.

CLOVEN HOOF

Cloven hoof marks might suggest the presence of the Devil, and that he's walked through your life. However, get the design wrong and people will think you let a goat stand on you.

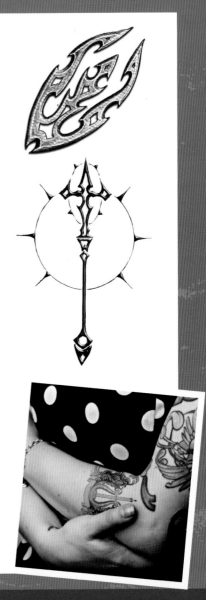

Top right and center: Two trident tattoo designs.
Right: A harp or lyre can also signify a
classical muse, see page 56.

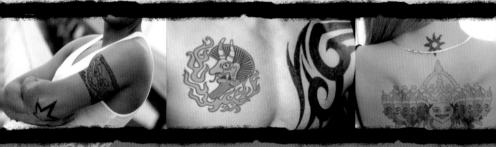

HINDU DEMONS

There's some argument over whether or not "demons" in the Western/Christian sense—malevolent beings who bring about suffering in mankind—actually exist in Hindu mythology. In theory mankind brings about his own suffering through the actions of karma, rather than being affected by external forces. However, there are certainly troublesome, warring spirits who feature in the Hindu epics the *Ramayana* and *Mahabharata*, and who battle with the gods and heroes described there.

RAKSHASAS

The Rakshasas are potential candidates for tattoo art, to display an interest in Hinduism and Hindu mythology or a belief in their influences on the world. Rakshasas are powerful spirits with magical shape-changing powers, sometimes described as man-eating creatures with venomous nails. Their king, Ravana, has 10 heads and is a formidable warrior, as is his brother Kumbhakarna. In carvings and images illustrating the *Ramayana*, these Rakshasas are shown embroiled in slaughter, riding chariots through the fray, making them ferocious subjects for tattoos.

OTHER CHOICES

Other Hindu demons include Kali (a separate demon, different to the goddess Kali), a sword-wielding source of evil who is fond of drinking and gambling; Vetalas, who inhabit corpses; and Pishachas, demons fond of darkness and cremation grounds who may possess humans. Described as dark colored with red eyes, images of Pishachas are certainly intimidating.

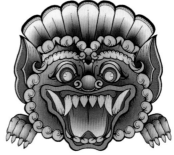

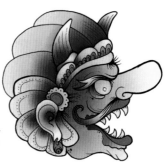

Artistic interpretations inspired by Hindu demons. Left: Garuda. Top and center: Two interpretations of Rakshasas. Right: Vetala.

BUDDHIST DEMONS

Buddhism embraces demons in various forms, representing metaphorical blocks on the path to enlightenment, or genuine malevolent spirits.

A tattoo of a Buddhist demon might point to a belief in the Buddha's teachings, a wish to overcome the obstacles and become enlightened, or an acknowledgment that demons will get in the way of that goal.

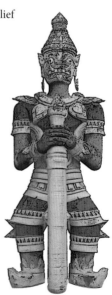

MALEVOLENT BEINGS

Buddhist demons include Mara (or Devaputra Mara), seen as anything from a slight nuisance to the living embodiment of evil in the world, and Lord of the Dead. Mara tempted Buddha on several occasions to distract him from enlightenment—without success. Buddhist art features many other malevolent beings—hardly surprising for a faith born in part among hostile mountains—and could be a good source of inspiration for those seeking a demon tattoo.

JAPANESE ONI

Oni are hideous creatures from Japanese folklore, often appearing as two-horned demons or ogrelike beings. They're violent, cruel spirits said to bring disease and disaster—and in some versions, are not averse to eating humans.

As tattoos they're frightening and intimidating, but may also carry some of the more modern interpretations of the oni spirits: they're invoked for protection and used to drive away bad luck, much like Western gargoyles (see page 84). They may also point to an appreciation for Japanese culture and spirituality, especially when combined with other traditional Japanese tattoo elements, such as features from the natural world, dragons (see page 72), koi, and tigers (see page 118).

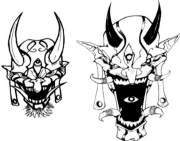

Right: Oni could be surrounded by cherry blossom and natural scenes to contrast the grotesque.

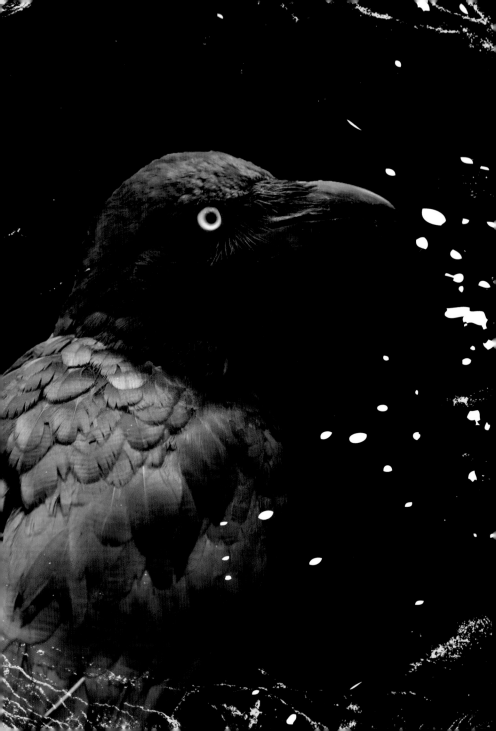

ANIMALS

Animal tattoos can suggest the real-life characteristics of the creatures themselves, and project them onto the wearer like a totem: the strength of bears and tigers, the cunning and pack loyalty of wolves, or the swiftness of snakes and eagles. But they can also have spiritual significance based on those qualities, or because of direct references in religious texts: lions can represent Christ, or jaguars the underworld, for example.

In fact, some of humankind's earliest artistic efforts, from carvings to cave paintings, were representations of animals. So it's hardly surprising that the desire to depict lions and tigers and bears (oh my) has continued throughout the ages—although we tend not to show as many saber-toothed tigers and mammoths these days, even in tattoo form...

LIONS

As a symbolic character, the lion has been a mainstay of major religions the world over for thousands of years, as well as appearing in numerous folk tales and fables, contemporary literature, heraldry, and even cave art.

RELIGIOUS INDICATIONS

The lion's role as king of the animals links him to three major world religions: Christ is often represented by the image of a lion in his role as "king of kings," and Buddha and the Hindu god Krishna are associated with lions. Followers of Christianity, Buddhism, and Hinduism might choose a lion tattoo to signify their faith, along with the lion's symbolic traits of strength, courage, and nobility, and associations with the sun, light, and therefore knowledge or enlightenment.

On a related note, the name "Singh," taken by millions of Sikhs and Hindu Rajputs, is an ancient Vedic word for "lion," providing a further spiritual signpost, albeit a slightly more subtle one.

MYTHOLOGY AND HISTORY

In African mythology the lion was both a creative and a destructive force and could represent these conflicting powers in tattoo form; overcoming a lion (real or symbolic) was also seen as an important rite of passage. Lions and lionesses were also sacred to the ancient Egyptians and Greeks, who saw them as warrior spirits. Inked lions could therefore embody courage in battle or physical strength in general, and attaining manhood.

Lions appear in Chinese and Japanese mythology as guardian spirits (see Foo Dogs, page 76), but they also bring luck when the Lion Dance is performed at Chinese New Year and other festivals. A tattooed lion in this form might bring good fortune to the wearer (improved dancing abilities are not guaranteed).

NEGATIVE CONNOTATIONS

A cautionary tale: lions are sometimes regarded as proud, arrogant, or even lazy, and as tattoos they could equally embody these qualities.

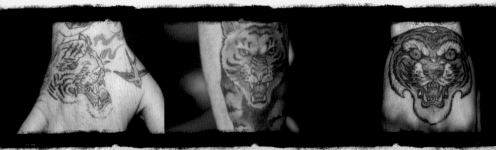

TiGERS

The lion might rule the roost in Europe and Africa, but in the Asia and the Far East the tiger is king of the beasts. Tigers represent similar qualities of strength and power as lions, but also of violence and destruction, making them tattoos that can intimidate as much as they can inspire.

MYTHOLOGY

Tigers appear in different forms throughout Eastern mythology. Various Hindu gods and goddesses (particularly Shiva and Durga) are depicted riding tigers in art and statuary, so tattoos of these images might appeal to Hindus or those interested in Hindu faith and deities. Tigers also appear in Buddhism as senseless creatures representing anger, so could be cautionary tattoos warning the Buddhist wearer of destructive emotions.

Tigers are also incredibly important in Chinese and Japanese

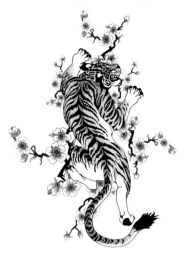

mythology, where they can represent the highest warrior, and certain schools of martial art incorporate tiger movements into their styles, focusing on power and ferocity. The tiger is particularly significant in relation to the dragon, which is his spiritual opposite. In traditional images (and indeed Japanese tattooing) the dragon and tiger symbolize the battle between our higher and base natures respectively, with their positions in relation to one another showing which we believe to be dominant. An equal placement suggests balance, a dragon on top shows we're led by our higher nature, and the tiger on top suggests we are ruled by our darker side. As tattoos the tiger can point to all these things, as well as the paradox of terrible beauty existing within one creature—much like people.

PROTECTION
On a lighter note, the tiger is also viewed as lucky or able to ward off evil, guarding temples and homes in China, so a tiger tattoo could simply be a protective one, using its fearsome appearance for good. (It's unlikely that Tigger will have this effect, though.)

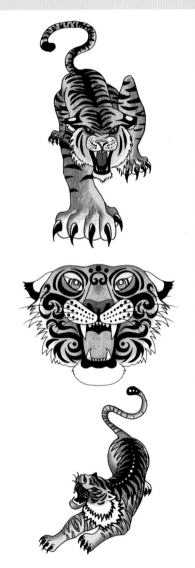

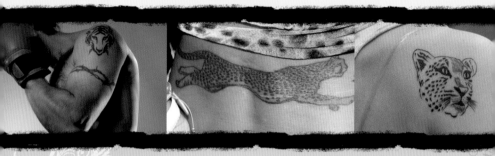

JAGUARS

The largest South American wildcat, the jaguar is a proficient hunter on land and in water; it's also happy to hunt during the day and night. This impressive adaptability might help to explain the jaguar's revered status among Mesoamerican cultures.

The jaguar was (and to some extent still is) important to many indigenous peoples throughout South America, where it was claimed to be a shamanic companion, a guide to the spirit world, and even a shape-shifter.

Mayan gods shared many jaguarlike attributes and images of the cat appear throughout their culture. It was seen as a spirit of the underworld and of fertility, and jaguar pelts, teeth, and claws were worn by nobility and warriors as totems of courage and high status.

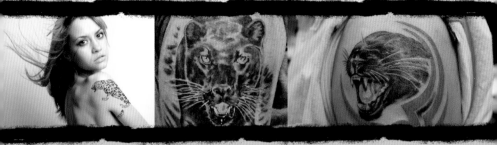

MYSTERY

Jaguar tattoos carry the physical associations of the big cat, but also hint at ancient magic and the underworld, making them a mysterious and enigmatic tattoo choice.

PUMAS

Also known as cougars, these wildcats had a significant influence on Inca civilization: their sacred city, Cusco, was said to be laid out in the shape of a puma.

Like the jaguar, pumas are sometimes linked with shamans and viewed as totem or spirit animals, and to some Native American tribes their cry is a harbinger of death (lucky tattoos are silent, then).

As a tattoo they might be worn for many of the same reasons as the jaguar, or in admiration for the hunting prowess of an animal that can bring down prey many times its size.

121

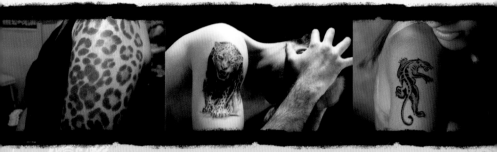

LEOPARDS AND PANTHERS

Members of the same family (panthers do have spots if you get close enough to look), these cats are widely famed for their strength and hunting ability, which is a big part of their symbolism in tattoo terms.

However, the leopard is also associated with shamans, and leopard skin was worn by Egyptian priests as a way of protecting them from evil spirits—leopard-spot tattoos might be chosen for just this reason. Considered especially dangerous by the Chinese, panthers, meanwhile, also carry undertones of rebellion and sensuality.

SNOW LEOPARDS
Tattoos of snow leopards, mysterious and solitary animals found in the Himalayas and other mountainous regions of central Asia, might symbolize independence or have associations with Buddhism, the principal religion of those regions, which includes many legends concerning the animals.

Top: Leopard. Below: Panther.

CATS

The household cat takes on many spiritual guises, depending on the religion or mythology you choose.

CONTRARY TYPES

A cat may be a companion of Satan, a witch's familiar (and by extension representative of feminine power and independence), the daughter of an Egyptian sun god, or, in Norse mythology, a sign of bad luck if it's black and crosses your path. Conversely, to the British and Japanese a black cat is lucky (not for British and Japanese mice), whereas to Buddhists the cat is a steely creature untroubled by the death of Buddha.

A cat tattoo can embrace any and all of these symbolic meanings, because as any cat owner will tell you, the animals themselves are somewhat contrary and hard to pin down.

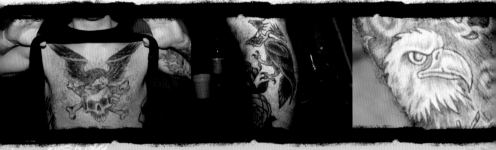

EAGLES

The eagle has been important to many religions and civilizations and carries a wealth of symbolism when it appears as a tattoo.

A popular symbol of strength and power to kings and warriors, the eagle can represent leadership and courage, as well as clarity of sight and independence.

Associations

Eagles are associated with John the Baptist in Christianity, so might be tattooed as a sign of faith; equally the Hindu deity Garuda, the mount of Vishnu, has an eagle's wings and beak and appears in many texts (including the Bhagavad Gita); while eagles were a sign of the sun to some Native Americans, and important totem/crest animals to the Northwestern tribes such as the Haida.

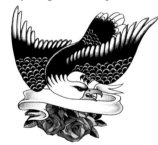

An eagle tattoo can indicate a general sense of soaring spiritual freedom, but may also point to specific beliefs depending on the interpretation of the wearer, and the design itself.

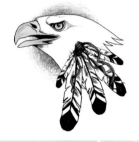

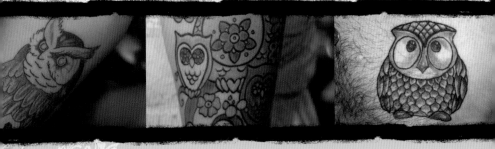

OWLS

While we primarily see them today as symbols of wisdom, owls have historically taken on more shadowy meanings.

In native North and South American cultures they have been synonymous with death and the spirit world, or with the souls of the deceased. Likewise in Africa and Europe owls tend to have magical associations with witches, wizards, illness, and general creepiness—not helped by their eerie cries in the night and unsettling ability to move without sound.

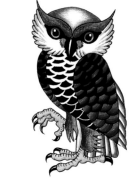

An owl tattoo might symbolize belief in a particular superstition or folklore, or indicate an attraction to witchcraft and magic. An owl might also make the wearer feel closer to the departed or suggest clear-sighted wisdom through the murk of death.

DOVES

Most obviously a Judeo-Christian symbol, a dove tattoo can indicate a few different aspects of faith.

A dove brings Noah an olive branch, signifying the end of the great flood and symbolizing hope, and ultimately perhaps God's mercy. Doves also represent the Holy Spirit, which comes upon Jesus like a dove at his baptism, and are a potent symbol of peace, itself an important Christian concept (the peace of knowing God).

MESSENGER

Carrying on the "messenger" theme suggested by the olive-branch story, doves were viewed as omens of either good or evil by some Celtic nations, and as messengers signaling the end of a battle in Japanese mythology, again linking the bird to peace. A dove tattoo might equally hold this meaning for some wearers.

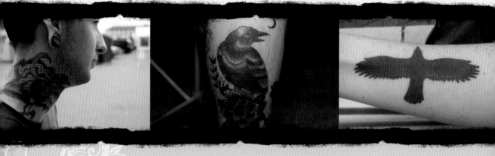

CROWS AND RAVENS

These gloomy birds share many of the same symbolic meanings, appearing as omens of bad luck, ill will, and even death (helped along by the crow's status as a carrion bird), making them appealing tattoos to those attracted to the darker side of life.

The raven is the titular bird of Edgar Allan Poe's Gothic poem, tormenting the protagonist with the single word "Nevermore," and a tattoo of this haunting presence might suggest Gothic persuasions.

However, it's not all black. Crows are messengers to the gods in Scandinavian folklore, warrior spirits in Irish mythology, auspicious birds to the Japanese, and sacred symbols of the Greek goddess Athene. Ravens, meanwhile, can also represent the creator/ trickster god of the Pacific Northwest, simultaneously getting up to mischief and bringing mankind water and fish, as well as conjuring the world into being. Not bad for one bird.

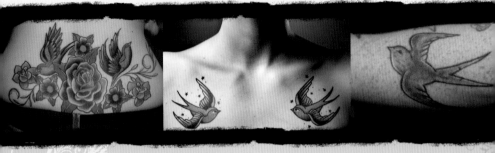

SWALLOWS

For small birds, swallows manage to pack in a fair bit of symbolic meaning.

As seasonal visitors they announce the arrival of spring, giving them associations with rebirth and therefore resurrection, so they're potentially suitable as Christian tattoos, and have also symbolized pilgrimages to Mecca for Muslims. As they appear in Egyptian iconography on boats sailing to the underworld, and are mentioned in the pyramid texts (carved between 2400 and 2300 BCE) as the "imperishable stars," they can also have links to the souls of the dead, making them a possible choice for memorial tattoos (see page 148).

NAUTICAL ASSOCIATIONS
On the same theme, nautical superstition has swallows carrying the souls of drowned sailors to heaven, and in tattoos a swallow with a pierced heart commemorates a companion lost at sea. However, to see a swallow tattoo on another person may not signify spiritual meanings, since in naval tradition once you've clocked up 5,000 nautical miles you've earned a swallow tattoo—and a bit of a rest, probably.

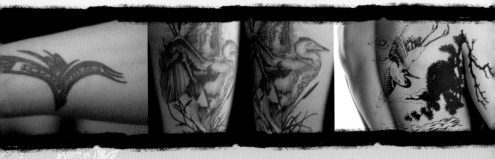

CRANES

Cranes have spiritual meaning and mythological associations for many cultures around the world.

PACKED WITH SYMBOLIC SIGNIFICANCE

Cranes have come to be images of peace in postwar Japan, but have had symbolic meaning in Japanese mythology for centuries. They represent longevity—or even immortality—as well as joyous love (thanks in part to their mating dance) and fidelity, since they mate for life.

In the West the birds are known for their long flights and might be linked to independence and the flight of souls to heaven, but also sociability—the birds often nest in large numbers—as well as similar expressions of joy to those of their Oriental counterparts, thanks again to their distinctive dance. Cranes also feature in pre-Islamic Arabian myths and Egyptian mythology, so they have plenty of symbolic resonance when they appear as tattoos.

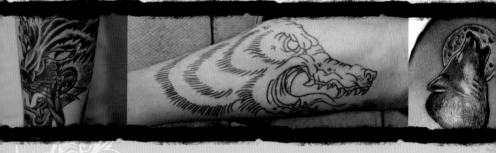

WOLVES

Wolves move swiftly through shadows and hunt at night, making it easy to link them with black magic and the underworld.

As predators of lambs and sheep they are the natural enemy of the shepherd, and by extension a wolf tattoo could represent the Devil, the antithesis of Christ, who is the good shepherd in Christian ideology. There are also many tales (positive and negative) of wolves in Native American folklore, providing a rich source of tattoo designs.

ANCIENT MYTHOLOGY

In Roman mythology the she-wolf suckles infant twins Romulus and Remus—Romulus will go on to found Rome. Symbolically this is one of the more positive aspects of the wolf, and as a tattoo may point to Roman or Italian heritage, or appreciation of classical mythology. Elsewhere the wolf is seen in myth and folklore as mysterious, cunning, and ferocious, particularly the Norse wolf, Fenrir, slayer of the god Odin.

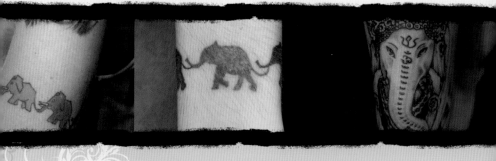

ELEPHANTS

Elephant-headed Ganesh, the Hindu god, is the most instantly recognizable spiritual form of the elephant, worshiped throughout India, and tattoos of his image would act as signs of devotion.

Elephants are generally revered throughout Asia. Painted beasts bless the faithful during religious festivals and bring luck, so an elephant tattoo might fulfill the same function for those without access to a pachyderm.

In African fables the elephant is wise and compassionate; the real-life version is able to navigate its way back to watering holes, creating the Western notion that the elephant never forgets, making it an ideal choice for memorial tattoos (see page 148).

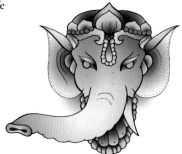

BVLLS

Bulls have been regarded as sacred beings since man first painted on cave walls, and there are many potential symbolic meanings behind a bull tattoo.

THE ANCIENTS

Bulls were linked to the Egyptian god of the afterlife, Osiris, and so can represent eternal life and resurrection. To the ancient Mesopotamians the bull's horns represented the moon, symbol of night or death, while the Greeks saw in the bull immense power and strength (see Minotaur, page 61).

FAITH

A totally different interpretation exists in Judeo-Christian faiths. The false idol made by Hebrews in the wilderness was that of a golden calf, so a bull tattoo in this context could warn the wearer not to worship false idols.

BEARS

Wherever bears have existed, they've been worshiped as creatures of incredible strength and a fiercely protective nature. From Japan to Finland, bears are variously regarded as forefathers of humanity, or even heathen animals to be tamed by Christian saints.

Bear claws and figures in North American and Pacific Northwestern iconography make for striking tattoos, suggesting totem animals and creatures linked to shamanic power. The bear's rising from hibernation can also signify the awakening of the subconscious and slowly attained wisdom, although possibly not in the case of Winnie the Pooh.

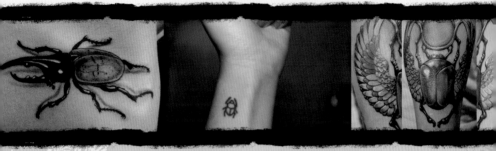

BEETLES

The ancient Egyptians attached great importance to scarab beetles.

Their rolling of balls of dirt into holes in the ground symbolized the motion of the sun across the heavens, so a scarab beetle tattoo can signify the sun. As the sun rises and sets in a regular cycle, scarab tattoos can also point to the cyclical nature of life and notions of rebirth.

This kind of inkwork can have another handy purpose. Images of scarabs were buried with mummies and were said to help persuade Osiris, god of the underworld, to let souls into the afterlife. A scarab tattoo might just have the same effect, if you think you'll have an appointment with Osiris when the lights finally go out.

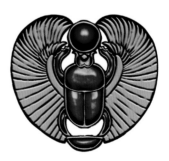

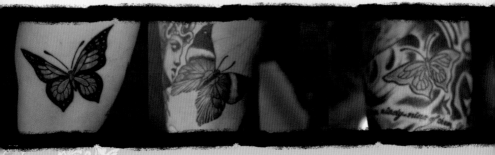

BUTTERFLIES

Possibly the most popular of all insect tattoo designs, butterflies carry with them ideas of rebirth and change—and consequently the more ambiguous idea that nothing is permanent.

Butterflies feature in various mythologies, from Mexican warrior priests to Japanese samurai lore, where they represent the souls of fallen soldiers. To the Aztecs they signified the soul or an individual's final breath, and they have a similar meaning in Greek mythology, where Psyche—the human soul in divine form—is depicted with butterfly wings. If you're looking for something representing the beauty, fragility, and changing nature of the soul, you've come to the right insect.

SERPENTS

Few creatures can boast more popularity in tattoo art than the snake, which carries sinister undertones without even trying.

CHRISTIAN CONNOTATIONS

In the Bible the snake—Satan in disguise—lures Adam and Eve into committing original sin by eating from the Tree of Knowledge, condemning humanity to exile from the Garden of Eden. Consequently a serpent tattoo can symbolize sin and the Devil (although later appearances in the Bible are more positive), as well as giving in to temptation and eating forbidden fruit.

SEX AND THE SERPENT

Speaking of forbidden fruit, as phallic symbols (and by association sin and temptation), snakes and snake tattoos can also be overtly sexual in meaning, and you can either revel in this, or wear a snake tattoo

as a chastening reminder that sex, in whatever form, can always turn around and bite you (and not in a good way).

MANY MORE ASSOCIATIONS
However, snakes in tattoo art aren't all bad. Their skin-shedding ability points to rebirth and renewal, and the ground-dwelling snake signified the underworld to Egyptian and American cultures. A serpent shielded the meditating Buddha according to some legends (and statues), while the "Rainbow Serpent" is an important figure in the creation myths of the Australian Aborigines, and features prominently in their artwork. Alternatively, in the northern hemisphere the Norse "World Serpent" coils around the Earth and represents the sea. For adherents of any of these faiths or world views, the snake makes for a powerfully relevant tattoo.

As if this weren't enough, snakes in combination with skulls represent immortality, and the serpent shares many of the symbolic traits of the dragon in Far Eastern mythology (see page 72), where dragons are much more snakelike than their Western cousins. On top of that, the serpent eating itself, Ouroboros, is a complex symbol of eternity (see page 37), while snakes crop up in Greek mythology as Medusa's hair, portents of doom before the fall of Troy, and more. Actually, it might be quicker to list what the snake *doesn't* symbolize.

WORLD RELIGION

As a constant reminder of your beliefs, and as a visible proclamation of faith, it's hard to beat a tattoo. Designs linked to the major world religions can vary from simple crosses to elaborate renderings of Hindu gods, but all can serve the same devotional purpose. It's also possible that for some people the actual process of getting a tattoo—which can hurt—is part of the reason to get one: suffering for your faith shows you take it seriously, and certainly has links with ancient tribal tattooing practices.

Of course, you don't actually have to be a believer to get Christian, Buddhist, or Hindu inkwork—the church of tattoo welcomes all comers and images from the world religions can be very powerful in their own right, working on an artistic level as well as a spiritual one.

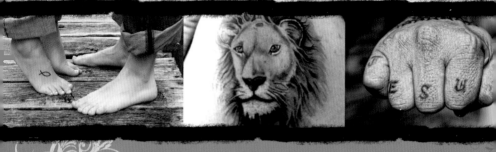

CHRISTIAN SYMBOLISM

Christian inkwork embraces signs and symbols that have been in use for thousands of years.

A common symbol is the fish glyph. It was originally a secret sign that allowed early Christians to identify one another. The Greek word for fish, "icthus," became the acronym *Iesous Christos, Theou Uios, Soter* —"Jesus Christ, Son of God, Savior."

The Celtic triquetra (see page 200) is used as a Christian image thanks to its triadic grouping. Any image incorporating three elements unified into one can come to be a symbol of Father, Son, and Holy Spirit—making the trefoil, intersecting circles, or even a triangle signs of belief.

The natural world has similar inspiration as lion, scarab, and even phoenix designs are representative of Christ. The sun is also a popular choice, representing light in darkness, Christ as the light of the world, and the creative force of God.

Finally, images of the Holy Grail represent Christ's cup from the Last Supper on one level, but symbolically the classic "grail quest" is a search for spiritual awakening and knowledge of God.

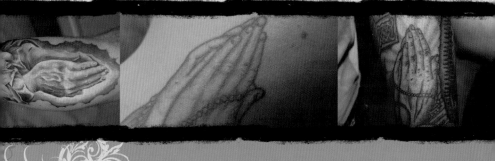

PRAYING HANDS

The original praying hands drawing was the work of German artist and printmaker Albrecht Dürer, created as an altarpiece in the sixteenth century (and predating tattoo flash by quite some time—if only Dürer had known).

A simple but striking image of piety, the praying hands symbolize prayer and devotion in tattoo art and might be combined with other elements of specific faiths—rosary beads, for example, if the tattooed devotee is Catholic—or more general religious symbols of shining light, halos, or perhaps thorns, harking back to the crown of thorns worn by Christ.

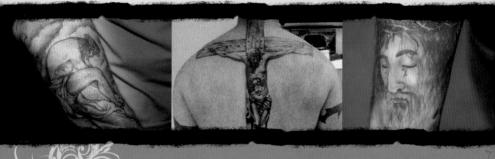

JESUS

There is almost no limit to the ways in which Jesus, the son of God in Christian ideology, can be represented in tattoo art. From realistic portraits to pixelated abstract images, the features and figure of Christ are a clear expression of faith, proclaiming the wearer's beliefs and serving as a reminder of their religion.

PORTRAITS

Those getting inked may choose a design that reflects their individual relationship with, or view of, Jesus, or one that best illustrates particular elements of his life, as written in the scriptures. This might include him preaching, healing, or being crucified—a potent symbol throughout Christian iconography and no less so in tattoo art. Head and shoulders portraits are also popular, and it's interesting to note how the

features, skin tone, and expression
of Christ vary in representations
from country to country, just
as he is depicted differently
throughout the world in
manuscripts, paintings,
sculptures, and stained glass.

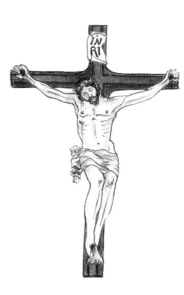

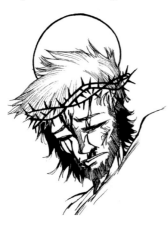

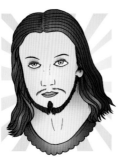

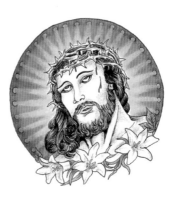

VIRGIN MARY/MADONNA

As the mother of Jesus, Mary holds great significance throughout the Christian faith, and this is reflected in devotional tattoos.

LIFE AND DEATH

Tattoos might illustrate Mary herself, perhaps showing her carrying the infant Jesus, and her image also signifies the virgin birth and the miraculous power of God. Another influential design borrows from Michelangelo's *Pieta* statue, which shows Mary cradling the crucified body of Christ and mourning his death.

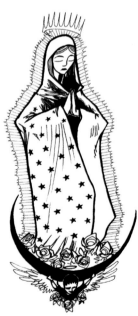

GUIDANCE AND PROTECTION

The Madonna can also take on a symbolic aspect representing compassion, love, protection, and guidance. She may appear in tattoos as a robed figure, gazing downward, bathed in light to show her holiness and capacity to illuminate the path of believers.

A SAILOR'S PIETY

Mary's image was traditionally worn by sailors, who believed a tattoo of the Virgin on their backs might cause anyone administering the lash to ease off slightly.

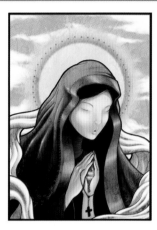

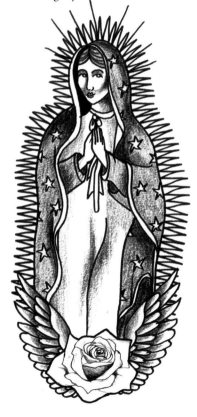

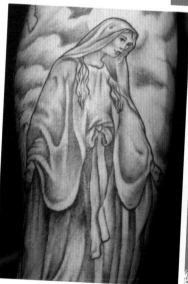

One of the most prominent figures in the Catholic Church,
The Virgin Mary is the most regularly tattooed religious icon.

coptic tattoos

The Coptic Church is an ancient branch of Christianity tracing its roots back thousands of years to the earliest Egyptian converts to the faith. Coptic tattoos—most notably a distinctive cross—are often worn by Copts on their wrists, and tattooists operate in the holy city of Jerusalem for just this purpose.

Coptic tattoos applied by priests using woodblocks were worn throughout the centuries by Crusaders and pilgrims to the Holy Land, as proof of their journey and as tokens of their devotion. One might serve an identical purpose today, although your tattooist won't ask for your proof of pilgrimage, since instead it is an emblem of faith and wider Christian spirituality.

FINE ART

Religion has inspired some of the greatest artists of all time, and memorable religious paintings—particularly from the Renaissance period—continue to influence tattoo art.

Elements of larger images, for example sections from Michelangelo's paintings on the ceiling of the Sistine Chapel in Rome, find their way into religious tattoos and act as demonstrations of faith. Equally, tattoos can encapsulate larger images—such as Leonardo da Vinci's *The Last Supper*—with all the complex symbolism they contain.

WIDER COMMUNITY

Of course religious art isn't limited to Christianity, and tattoo designs can take inspiration from any faith. Inked depictions of hieroglyphics, carvings, manuscripts, and holy texts can all demonstrate a wearer's faith, as well as showcasing the skill of the tattooist themselves.

MEMORIAL TATTOOS

People have been using visual art forms to commemorate the departed since time immemorial, from tapestries to cave art, cenotaphs to ancient Peruvian funerary towers, and of course the pyramids.

A physical reminder of the deceased can honor their lives and help people to cherish their memory, and a tattoo can serve just this purpose. The very act of inking the skin can be a cathartic process, helping the bereaved move forward while still celebrating the life (or lives) of their loved ones.

REPRESENTATIONS

Memorial tattoos can take any form you choose, and may be inspired by any faith. Some people choose an old-school motif of swallows, hearts, and scrolls bearing the names of the departed, for example. Others might choose a realistic portrait of the person in question. You might equally choose an explicitly religious image, such as a weeping angel or a tombstone, or even a representation of a funeral pyre.

Gods and goddesses of the dead, inscriptions, and animals or objects associated with the person being commemorated are also popular choices. You might choose something that reflects your hopes for the spirit of the deceased, for example a dove for ascension to heaven, an underworld spirit such as Osiris, or a mantra reflecting a belief in reincarnation. Of course, if your expectations are lower, a devil is as much a memorial as an angel.

EXTRA CARE

Whatever you choose, it's worth bearing in mind that memorial tattoos are extremely personal and can carry more emotional weight than others, so it's important to think carefully about the design and choose something that will have a lasting relevance, rather than inspiring regret.

Below left: The early stage of a line outline for a memorial tattoo. The swallow has its own significance as part of a memorial tattoo (see page 128).

TRADITIONAL HINDU

The concept of tattooing is nothing new to the Hindu faith—certain elements have long traditions, involving simple designs of lines and circles to act as marks of devotion. Equally, the use of henna (or mehndi) is a common part of religious observances, particularly weddings.

Hindu tattoos not representing specific gods might include symbols (such as *Om*—see page 38), scripts and mantras, images of holy sites and temples, or extracts from the principal texts of Hinduism (such as the *Puranas*), or the great Indian spiritual Epic, the *Mahabharata*.

BRAHMA
Of the three principle Hindu deities, Brahma—the creator—has declined in popularity over time. However, images of him appear throughout Hindu culture and make for distinctive tattoos, variously depicting him with four or five heads, a white beard to signify his eternal lifespan, and sometimes red skin.

Importantly, Brahma isn't to be confused with Brahman—the latter

is the supreme being and spiritual essence of all creation; the former (and indeed all Hindu gods and goddesses) a manifestation of one aspect of that being. Clear?

VISHNU

Vishnu encompasses past, present and future and his role is that of keeping creation in order, restoring and protecting it where necessary.

Vishnu is said to have appeared on earth nine times (some schools of thought regard the Buddha as his ninth incarnation, or "avatar"), and is prophesied to appear once more at the end of the Kali Yuga—our current age. Tattoos of Vishnu point to the characteristics he embodies such as strength, wisdom, splendor, and energy, as well as conferring his protection on the wearer.

SHIVA

Shiva is often seen as the destroyer and can manifest himself in many terrible forms, but he also has positive aspects and can be regarded as the source of knowledge and even the universe itself.

Shiva symbolizes both the sacred and the profane. He's at once identified with phallic symbolism (and rather flexible erotic adventures according to some temple carvings in Madhya Pradesh) and the embodiment of the holy dharma, seen cavorting, dancing, battling, and in deep meditation across representations.

Top: Two depictions of Vishnu.
Below: Two depictions of Shiva.

These contradictions are the essence of his divinity, making him a powerful spiritual tattoo showcasing the beautiful and the dreadful in equal measure.

GANESH

Chubby and childlike with an elephant's head, Ganesh is regarded by some as the spirit of prosperity, creativity, and peace, and a help in removing obstacles. With his many arms he can symbolize protection, righteousness, the cycle of life, and more, and is a genial, benign companion to accompany the wearer.

HANUMAN

Likewise, Hanuman the monkey god is the deity of acrobats and wrestlers and a chief protagonist in the battle against demons in the Hindu epic "Ramayana," making him appropriate for anyone requiring nimble protection from malevolent spirits.

KRISHNA

Krishna is the hero of the Bhagavad Gita, a sacred Hindu scripture. He is an avatar—incarnation—of Vishnu, who explains the route to spiritual peace and salvation in this life,

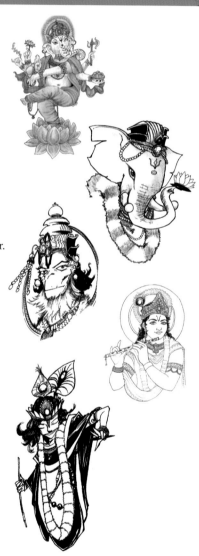

Top and directly below: Two depictions of Ganesh. Center left: Hanuman. Center far right and below: Two depictions of Krishna.

through selfless action, knowledge, and devotion. As a tattoo he may take the form of a dark-skinned, black-haired young man playing the flute, who shows the path to enlightenment and embodies both earthly love and divine love between humans and gods.

KALI

Somewhat different from the graceful Krishna, Kali is a manifestation of Durga, a terrifying goddess and destroyer of demons. Usually slathered in gore and draped in skulls, Kali has many arms and bears a variety of weapons, and her worship can demand animal sacrifice in some temples. Her tattoo incarnation might exist to strike fear and batter demons, but also to point to the violence and destruction ever-present in life. She's probably not one for prom queens or the faint-hearted.

LAKSHMI

Lakshmi, on the other hand, is the one you bring home to meet mother. Embodying grace and beauty, she's a consort of Vishnu and might appear seated on the lotus flower, itself a symbol of creation and spirituality.

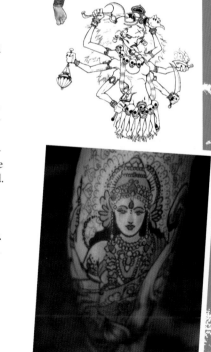

Above: Two tattoo designs of Kali.
Right: Lakshimi is an elegant beauty and a symbol of fertility.

BUDDHA

Tattoos of the Buddha can represent the Buddhist faith, an appreciation of the Buddha's teachings, or the wish to be enlightened, since the name Buddha means "the awakened one."

CHANGE

Just as there are various schools of Buddhism, from the colorful Tibetan schools to the austere, minimal, Japanese Zen schools, so the Buddha can appear in different forms as a tattoo (including in female form or in a light-hearted scene, both illustrated to the right). However he appears he can act as a reminder of Buddhist principles and gently prompt the wearer to be compassionate.

Of course, tattoos may be seen as an earthly attachment, which Buddhism argues is the cause of all suffering in the world, but they may equally act as a reminder that all things will pass, just as a tattoo will change and ultimately vanish along with the skin it adorns.

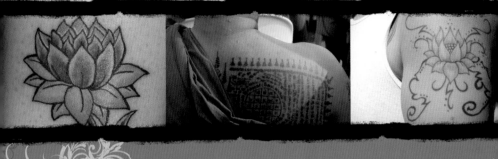

BUDDHISM

Tattoos pointing to Buddhist beliefs include prayer flags and prayer wheels, the heart mantra *"om mani padme hum,"* (usually written in Sanskrit and translated as "hail to the jewel of the lotus"), or the lotus flower.

The lotus is an important symbol in Buddhism, representing the Buddha's pure nature. Staying on the horticultural theme, the bodhi tree is another popular image, since the Buddha was enlightened underneath its branches after prolonged meditation.

TIBET AND TRADITION

Tattoo portraits of the Dalai Lama, the exiled Tibetan spiritual leader, suggest the Buddhist faith, but also a life lived according to peaceful, compassionate, spiritual principles. At the other end of the scale, traditional hand-tapped tattoos from Thailand are administered by

Buddhist monks and have various symbolic meanings, ranging from the purely devotional to those intended to deflect bullets—which are popular among soldiers.

Top: Tibetan demon offering bowls.
Below: Two depictions of prayer wheels.

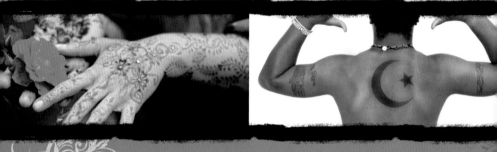

ISLAM

The Koran may or may not forbid tattooing, depending on the interpretation of some verses that refer to marking the body. However, those that do choose an Islamic tattoo will find plenty of choice when it comes to designs.

The star and crescent moon symbol is popular, acting as a general token of faith, as are verses from the Koran, although it's important to choose verses wisely and position them appropriately, i.e. near the heart and head.

CROSSOVER TATTOOS

There is also plenty of crossover between Islam and Christianity, so many tattoos have relevance to both faiths. For example, angels, Satan, and Adam and Eve make appearances in the religious texts of both ideologies, so could be appropriate for those wishing to signify the Muslim faith. Text and symbols from both faiths could even be combined to point to religious harmony for some wearers.

jUDAism

The Jewish faith shares certain beliefs with Christianity (and by extension Islam), so angels may be a relevant Jewish tattoo symbol, along with quotes from holy books, or figures such as Abraham or David, who appear in the scriptures and writings of both faiths.

Another important symbol is the hexagram or six-pointed star, which is believed to echo the shield worn by David in his battle against Goliath, and appears on the Israeli flag. A tattoo of the menorah, a candelabra with seven or nine branches, associated with Hanukkah, makes for a simple and clear way of signaling Jewish faith and beliefs.

Top right: Star of David with "love" in Hebrew at the center.
Right: "God" written in Hebrew above Jewish imagery.

SHINTO

Shinto is practiced throughout Japan, and has evolved alongside Buddhism to create a unique blend of faiths.

Sometimes Shinto is described as the religion for day-to-day living and birth, while Buddhism is the faith for dealing with death and the afterlife (although the actual relationship is rather more nuanced). Shinto has a wide-ranging spirituality that isn't contained in a single holy book; instead its beliefs and practices feature in numerous writings and folklore.

NATURAL SYMBOLS
Broadly speaking, Shinto (meaning "way of the gods") is concerned with spirits and the supernatural essence of the natural world. Tattoos might suggest Shinto practice (the religion is open to all and doesn't require you to profess yourself a believer) or affinity with Japanese culture, and may take the form of Japanese artwork, or more simply representations of Shinto shrines and *torii* gates, which mark the boundaries between sacred and secular spaces.

Left: An Amenonuhoko, *the heavenly jeweled spear from Shinto mythology.*
Top: An abstracted feather symbolizing Shinto's relationship with nature.
Below right: The torii *gate.*

PAGAN

The term "pagan" is a rather loose one that has come to apply to many forms of faith that fall outside the canon of Abrahamic religions such as Christianity or Judaism.

For the purposes of tattoos, pagan images might be inspired and influenced by Wicca (or modern witchcraft), neo-Druidism, the occult, and goddess-worship, with a strong connection to the natural world, sun, moon, and stars—and dancing around stone circles, if you like.

LIGHT AND DARK

As you'd expect, tattoo designs can vary from traditional representations of folk gods and goddesses to new-age renderings of celestial bodies and Wiccan images of pentagrams. Pagan images can suggest heathen dark arts but for most it's about paying due reverence to the spirits of the Earth. Happily, the "tattooniverse"

can embrace both world views and so pagan inkwork can be as light or dark as the wearer chooses.

Top: The Green Man, a figure symbolizing rebirth, is often associated with Pagansim. Below: An illustration of a celestial figure.

159

MAGIC AND MYSTICISM

Magic and mysticism can take many forms, from the conjurer pulling bunnies from hats to the voodoo priest of Hollywood horror, working black magic on unsuspecting victims. In between, there's the subtle mystery of the Tarot, clairvoyant crystal balls, new-age spiritualism, and of course fantasy, with its world of witches and wizards.

Any and all of these can inform tattoo art, and it doesn't stop there. Modern witchcraft is much more akin to a nature-based religion, appealing to witches of a very different kind, for example, while the power of traditional Thai tattoos is said to protect warriors and deflect bullets. Magic plays a serious part in the everyday lives of many people (you'd take anything that made you bulletproof seriously, after all), so there's definitely more than pointy hats and magic wands to be found here...

WITCHES

Are you a good witch, or a bad witch? Which? *Wizard of Oz* references aside, it's a valid question when it comes to tattoo art, and when considering witches in general, since they can appear in very different ways.

The Halloween versions of witches feature crumpled, scary old women dressed in black with long, pointy hats. They're the pantomime villains of childhood, warts and all, and exist as cackling, malicious characters that might amuse as much as they intimidate. They might also be associated with black cats, broomsticks, and cottages made of sweets.

TRADITIONAL REPRESENTATIONS

A more folkloric witch representation is of a woman associating with the devil or black magic. She might be dangerously seductive or purely terrifying, embodying dark forces and the more shadowy side of our nature, as well as representing great power and the ability to use magic and demons (or "familiars") to accomplish her will. This kind of witch can be sexy or sinister, and a tattoo for those who want to highlight their strength of character. A witch being burned at the stake can reflect historical fact, act as a horror tattoo, or be a metaphor for the persecution of powerful women.

NATURAL WITCHCRAFT

The modern take on witchcraft (including movements such as Wicca) points much more to the natural world. A twenty-first century witch is positive, rooted in the earth, and draws power from Mother Nature herself, so these tattoos might include natural elements and rely a little less heavily on black robes.

A TATTOO FOR ALL

A witch is not an exclusively feminine tattoo, but might also be appropriate for a man, or indeed anyone, who feels under a spell, or those who consider themselves bewitched by someone or something in their lives. It may also be chosen by people who are looking for a little magic, whether good or bad.

WIZARDS

Wizards appear throughout fantasy, folklore, and literature, usually as gray-bearded old men with robes, a staff, and a tall hat partially obscuring their features. They're generally seen as positive influences—although wicked wizards are far from impossible—offering wisdom, magic, and spells that they may have attained naturally or by extensive study.

One suggestion for the continuity of wizards' looks throughout the fantasy realm is that they stem from a common source—Odin, the Norse god, who was described in some incarnations as a wandering old man with a beard, staff, long robes, and pointy hat.

MULTILAYERED SYMBOLISM
A wizard tattoo may simply reflect a passion for the fantasy genre, however, there are layers of meaning beneath the robes. Wizards can represent the wisdom acquired by age, experience, and prolonged study, and as such may be characterized as guiding figures—as they are in Arthurian legend and *The Lord of the Rings*. Their magic, like that of witches, may be drawn from elemental forces and suggest links to the natural world, or the wish to shape events through supernatural powers, while the wizard's advanced years may

even point to archaic wisdom or an affinity for old-world learning, set apart from the modern era.

A wizard tattoo might also suggest an awareness of power and responsibility. Wizards have a force—magic—at their disposal, and must choose how they use it. Magic can be used for good or evil, or may be a slightly more ambiguous force highlighting the whims of the wizard. In Shakespeare's *The Tempest*, Prospero uses his magic to dole out both pleasure and pain, for example, so a wizard tattoo could point to the complex relationship between what strength we have, and how we use it.

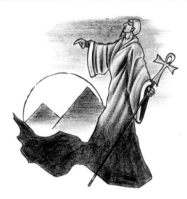

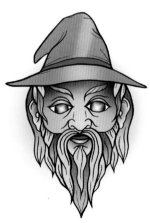

VOODOO AND ZOMBIES

Tattoo images of voodoo dolls and zombies owe more to Hollywood and popular fiction than to any real-life religion or practices.

In their screen mode, voodoo dolls exist to channel magic against the intended victim: stick a pin in the doll and the target feels pain. Under the thrall of the same magic, zombies do their master's bidding without question. Both images make for effective horror tattoos, suggesting fear and the influence of dark forces.

VODOU

Actual voodoo—or *vodou*—is very different. Varying forms are practiced in the United States, Haiti, and Africa, sometimes displaying a marked Christian influence, although this varies from region to region. Generally *vodou* shares a belief in a creator deity, who has nothing to do with the affairs of mankind, and many lesser deities and spirits that can be contacted by us to bring good or ill. "True" *vodou* tattoos may appeal to those with roots in the communities where it is practiced, or who share their beliefs, and might include *vodou* figures or symbols of spirits; but probably not dolls with pins in.

BLACK MAGIC

A current of forbidden sexuality and corrupted religious ceremonies tends to run through black magic imagery in popular culture, and tattoo imagery too.

Black magic (and voodoo, though incorrectly) is sometimes linked to Satan and devil-worship, often implying the use of magical powers for evil purposes. Tattoos might include occult images of pentagrams, inverted crosses, or seductive witches.

Views of magic, and black magic, differ widely. Some see the two as separate forms acting in opposition to one another, while for others they are the same thing. Tattoos allow the wearer to make their own distinction, and no one has been burned at the stake for it—yet.

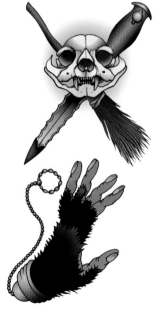

Top: A cat skull with a sacrificial dagger and a broom. Below: An evil monkey paw, considered a strong talisman of evil.

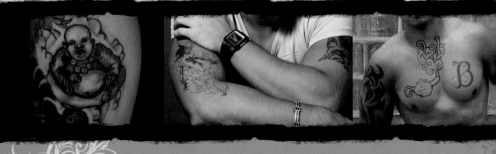

GEПİES

Thanks to a curious crossover in translation, the entity known as a genie can be interpreted in two different ways.

THE KORAП

The *djinni*, *jinni*, or *jinn* of pre-Islamic and Islamic culture are creatures that inhabit a parallel world to our own. In the Koran they are described as beings made of "smokeless flame," created by Allah as a race with free will in the same manner as humans. One of their kind is Iblis, who rebelled against God just as Lucifer does in the Bible; both are cast out until Judgment Day and have the power to tempt and corrupt mankind.

Conflicting descriptions of the *djinni* exist. The Koran isn't much more explicit than describing them as having a similar form to humans, while other sources and scholars depict them as men in white, vultures, and even dragons. As a tattoo, a *djinni* will appear as it does within the mind of the artist and wearer.

WESTERN GENIES

The Western form of "genie" probably comes originally from the Latin *genius*, describing a guardian spirit. The French word *genie* descended from this and was appropriated for European translations of *The Arabian Nights Entertainments*—or *The Thousand and One Nights*—which includes the tale of Aladdin and his lamp. The *jinni* of the lamp became the "genie" since the word sounded similar and had appropriately spiritual connotations.

Several centuries and a few Disney movies later, genie tattoos represent a spirit of immense power that is nonetheless constrained—the master of the lamp must use it wisely. Genies can serve and protect but also warn against squandering the powers we're granted in life: you only get three wishes in some versions of genie lore, perhaps reminding the wearer to be careful what they wish for.

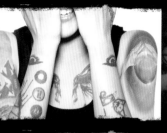
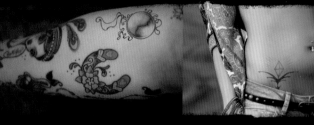

CRYSTALS AND CRYSTAL BALLS

Crystals are natural formations that are transparent and beautiful, and intimately linked to the primal forces of the Earth and nature, while crystal balls are inextricably linked to clairvoyance.

As a solid, strong object that can nonetheless be looked through, it's not surprising that crystals have traditionally been linked to powers of divination, wisdom, and insight in both ancient shamanic cultures and more recent new-age spiritualism.

A crystal tattoo can suggest a specific belief in particular crystals and their healing powers—according to some practitioners different colors fulfill different functions when placed on the body—but could hint at a more general spirituality. They're often combined with other images such as plants and animals, again

pointing to faith in nature, drawing strength and wisdom from the natural world, or channeling energy using the crystals themselves.

Crystals have also fulfilled magical roles in the realm of fantasy film and literature, where particular gemstones have powers that make them much sought after, and a crystal tattoo might be popular with fans of the genre for that reason.

CRYSTAL BALLS

The crystal ball has associations with clairvoyance and looking into the future. It's used in folk superstition as a way to predict fortunes and to see the outcome of events farther down the road, and a crystal ball might appear alongside old-school gypsy-woman tattoos to suggest just this meaning.

Crystal balls can appear in isolation too, pointing to a belief in the ball as a way to see the future, or even as a warning that the wearer has no crystal ball in reality and can't predict what's going to happen. It all depends what you see when you look into it. (Ask nicely before you start peering closely at people's tattoos, or your future might contain stern words.)

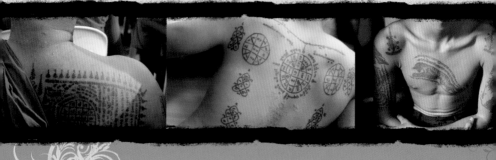

traditional Thai tattoos

A truly authentic traditional Thai (or *sak yant*) tattoo is very different to one that you pick from a wall of flash in your local studio and have inked on the spot.

However spiritual your tattooist, the tattoo just won't cut it if the following conditions aren't met:

- It must feature a traditional Thai image. This might be a Buddhist temple, a prayer written in Thai script, or a *yantra* image comprised of dots. It might be an auspicious animal, such as a tiger, dragon, or snake, and by taking on the image of the animal you're taking on its characteristics. (If it's a tiger, you'll be in good company, since Angelina Jolie has a traditional Thai tiger tattoo.)

- It must be poked by hand, in the ancient tradition, using a long needle-tipped bamboo pole, which is dipped in ink and speared under the skin. But not just any ink. Tattoo masters mix their own and may include special herbs and spices, or even, as legend has it, snake's blood, to add to the potency of the image. (This might also explain the fevers, fits, and convulsions of some supplicants after receiving their tattoo; although it could equally be the magic starting to work.)

- The artist should be a trained master, often a Buddhist monk, who works with an apprentice. The monk will be able to reach the pure, focused spiritual state required to imbue your tattoo with the right magical powers as he creates it; the apprentice might stretch the skin to be punctured while chanting mantras and prayers.

MAGICAL POWERS

If done properly, the end result is a tattoo that crackles with magical power because of the combination of design, process, and ritual involved in its creation. These tattoos are much sought after: people travel from all the over the world to the Wat Bang Phra temple festival to receive tattoos from the masters. The tattoo is about much more than mere superstition: soldiers choose them in the belief that done well, they can stop bullets.

When it comes to traditional Thai tattoos, only the real thing will do. Would you trust a bulletproof vest made by people who usually knit sweaters? Exactly. Better to find real monks, and real magic.

Artistic interpretations of Thai tattoos with a magical theme. Top: A skull tattoo in the Sak Yant style. Below: A modern Monkey Ling Lom.

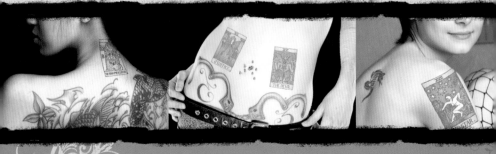

TAROT CARDS

The significance and symbolism of the tarot deck has fascinated many. The cards are often used for fortune-telling, and have echoes of magic and the occult surrounding them. Tarot tattoos appeal to those with knowledge of the cards, or to those who like the air of arcane mystery they generate.

Tarot cards are believed to date back to twelfth-century Europe—according to the *Oxford English Reference Dictionary*, the earliest surviving set is from 1390. A deck consists of 56 cards arranged in four suits, similar to a regular deck of playing cards but with the addition of knights to the court cards. There are also 22 cards representing different stages of life (including death) and astronomical/astrological bodies such as the sun and moon. Tattoo designs might include images of the cards themselves, or feature some of the figures and themes appearing on them.

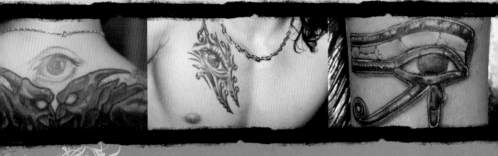

THE ALL-SEEING EYE

An eye that never blinks, and sees everything, could of course be the glowering eye of Sauron, as described in *The Lord of the Rings* and depicted many times in illustrated versions of the novels. However, the idea has existed from the time of the pharaohs, where the eye of Horus represented a watchful protector deity.

Since then different cultures have featured similar imagery, including Buddhist representations of the Buddha as the "eye of the world." The Christian version—sometimes known as the "eye of providence"—symbolizes the omniscient gaze of God, as well as the Holy Trinity, and often appears surrounded by sunlight—the image of God's power and love.

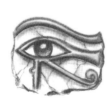

WATCHFUL EYE

The eye can be worn as a protective symbol or as a totem of one of the faiths mentioned above. It's also associated with the Freemasons, and those associated with that secretive world, and even appears on the Great Seal of the United States atop a pyramid. And, of course, it can mean that someone—God or otherwise—is always watching us, which can be reassuring or terrifying, depending on your world view.

NATURE

The natural world and wider cosmos beyond our own little blue planet are important themes in myth, legend, and religion. Plants, flowers, the mountains and seas and the stars themselves have been the subject of countless belief systems, which makes them flexible and varied subjects for tattoos.

Various creation myths exist around trees, for example, if you're looking for a natural symbol with a wide spiritual significance; if you'd like to focus on something smaller, on the other hand, the lotus is closely linked to both Buddhism and Hinduism. Mountains might house Greek gods or Peruvian earth spirits, depending on your point of view, while cherry blossoms can point to both life's beauty and the soul of the samurai; and of course Mother Nature herself can appear in (or on) the flesh. Throw in the sun and the moon, and there's a whole universe of meaning to choose from...

MOTHER NATURE

The idea of the Earth, nature or creation in general being represented by a woman or goddess has existed in various cultures for centuries—all tied in to fertility and a body (human or celestial) that incubates and brings forth life.

THE ANCIENTS

The ancient Greek pantheon of gods has Gaia as the earth mother, a primordial goddess. Through various unions she either creates or gives birth to the heavens, oceans, and mountains, making her the foundation of our world. Images of Gaia appear in both Greek and Roman art, as mosaics and in pottery.

In later Greek myths, Demeter is the earth mother whose daughter Persephone is abducted by Hades, god of the underworld. In a rage she refuses to let anything grow, starving humankind, until Zeus intervenes and arranges for Persephone to spend six

months in this world, and six in the underworld. Her absence brings about sorrow in her mother, and therefore autumn and winter; when she returns to the world, so does life in the form of spring and summer.

VARIOUS INCARNATIONS

Mother Earth as a fertile goddess (sometimes called Gaia, echoing the ancient Greek) is a key concept in Wicca, where she is regarded as the earth mother. In neo-paganism she represents all creation and is the object of many rituals and ceremonies. She also appears in South American Quechua mythology as Pachamama, the earth mother of the Andes.

THE ELEMENTS

Tattoos representing the classical elements (Earth, Air, Fire, and Water, and sometimes Ether) show a universe made of conflicting and complementary substances or forces. In the West they're the building blocks of the natural world, while Chinese philosophy sees them as shifting states of energy that perpetually create and destroy one another. Taoism has similar elements but includes qi (or "chi" to Westerners), an energy force which flows through all living things.

TATTOO DESIGNS

A tattoo of mother nature can represent fertility and love or respect for the natural world. Designs might be inspired by classical versions of Gaia or medieval personifications of mother nature, or show her wreathed in plants and leaves —literally the body from which everything grows.

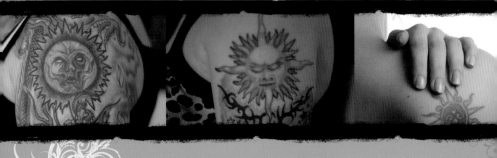

SUN

Humans have been worshiping the big shiny thing in the sky since we first looked up. At its most basic level the sun brings light and warmth and represents life. It's a symbol of rebirth, reincarnation, and the cycle of existence, "dying" beyond the horizon every night to appear again the next day, as if reborn.

ENLIGHTENMENT

The sun's rays bring about fertility and growth, but also banish darkness, which can symbolize the triumph of knowledge or wisdom (light) over the darkness of ignorance. In religious terms this can link the sun to Christ, the Holy Spirit, and Buddha, all described in terms of light or enlightenment. Likewise the sun and solar cults were hugely important in ancient Egypt, where again the sun was a potent symbol of rebirth as well as power.

POSITIVE SYMBOL

The sun has been represented in different ways by many cultures and civilizations, so tattoos can reflect this. Wearers might choose a simple solar disk, a representation of an Egyptian or Aztec sun god, or a Haida crest. Whatever the image, sun tattoos are overwhelmingly positive. The only irony is that, like all tattoos, they shouldn't be overexposed to one thing in particular: sunlight.

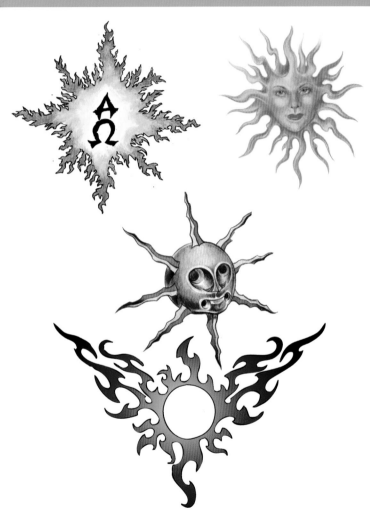

Four tattoo illustrations of the sun. The illustration in the top left surrounds Alpha and Omega, the first and last letters of the classical Greek alphabet that stand for birth and death. They represent the idea that the sun is the creator of all life on Earth and will one day destroy it.

MOON

Combined with the sun, a moon tattoo can represent all life and existence: day and night, beginning and end, alpha and omega; opposing forces unified as one. However, the moon doesn't have to play second fiddle to the sun, and can appear on its own.

With its regular phases and connection to the tidal motions of the oceans, the moon is often symbolically linked to menstrual cycles and therefore femininity and goddess-worship. In Western cultures the moon is generally seen as female—thanks to the influence of Greek and Roman mythology—but is viewed as a masculine form elsewhere—in Aztec culture, for example.

The moon features heavily in mythology, both as a benign goddess and a force influencing people and animals. The moon can help them or drive them mad—the word "lunatic" derives from "lunar"—or

provide them with something to howl at in the case of werewolves. Its association with night can lend moon tattoos an air of mystery or wickedness, particularly when linked to witches, the Devil, or the supernatural, but the moon can also be a source of solace, providing light in the darkness.

LUNAR REPRESENTATIONS

A lunar tattoo can be positive or negative depending on the whim of the wearer (or the tide of the moon), making it a flexible and popular celestial symbol. It might appear as a full moon or a crescent, or even as one of the many lunar deities that represent the moon, from the Greek Artemis or Roman Diana, to the Egyptian goddess Isis.

The shape of the moon is said to affect our mood and energy, and designs can also be customized to reflect this.

STARS

Symbolic or stylized representations of stars can refer to specific faiths—the Star of David for Judaism, for example, or an inverted pentagram for Satanism—but the celestial bodies on which they're based carry their own meanings as well, usually linked to the light they throw into the cosmos.

GUIDING LIGHT

Stars can represent guidance in the darkness and act as beacons of hope; they may also be the transformed souls of the departed looking down on the world. More explicitly, stars have played roles as portents in some faiths, such as for the arrival of Jesus, which was heralded by a star in the East that led believers to his birthplace. They have also featured in some Native American ceremonies, such as the Pawnee Morning Star ritual, which allegedly required human sacrifice to the morning star.

Tattoos of stars can signify a particular faith, but also a more general desire for light, guidance, and hope. They are also handy astronomical reminders of the infinite span of the universe and unending existence.

PLANETS

A tattoo of a planet, or the larger solar system, might suggest the wearer has turned the science of astronomy into their own personal religion, but the planets do have their own mythologies and, of course, they're named after Roman gods.

INFLUENCE

Planets were thought of as wandering stars by early man, and as messengers from the heavens. Although they've since lost this tag, planetary influence plays a large part in astrology, with different planets affecting the various star signs and consequently the fortunes of those born under them. Mars, for example, signifies ambition, strength, and courage and is the ruling planet of Aries; Venus rules Taureans and Librans, affecting their relationships and sex lives, among other things.

Tattoos of planets can hint at Greek and Roman mythology, but more strongly at a belief in the principles of astrology—a planetary tattoo of Venus may not guarantee better relationships (and more) for wearers born under the signs of Taurus or Libra, but you never know, it might help.

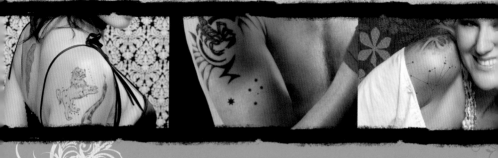

CONSTELLATIONS

Taking their names from animals, objects, or characters from mythology, the constellations can appear in tattoos as simple stars with connecting lines, or as more elaborate inkwork combining the outline of the constellation with the object it represents.

Tattoos can be a nod to the origin myths behind constellations, or reference their use as navigational aids. As the orientation and visibility of constellations changes depending on your location on Earth, and the Earth's position on its orbit around the sun, they might also be used to represent the night sky at the time and place of a person's birth, or on a date of personal significance.

ORIGIN MYTHS

The origin myths and different cultural representations of the constellations are varied and too numerous to elaborate on in detail here. As an example, the myths surrounding Orion—one of the most recognizable formations in the heavens thanks to three stars forming his "belt"—variously describe the constellation as Orion the hunter (Greek mythology); Nimrod the warrior (Hungarian

mythology); or Mriga (the deer, Indian mythology). Not all versions incorporate the same stars, and focus instead on the three stars forming the belt—Native American folklore describes them as the footprints of the god of the flea people.

In other words, there are almost as many variations as there are stars in the sky, making these very flexible tattoo subjects.

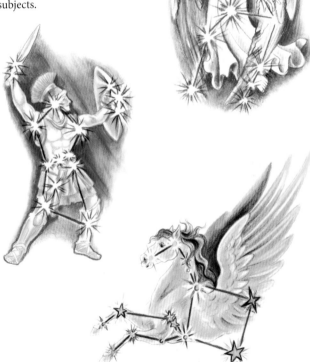

Artistic interpretations of constellations. Top: Virgin/Maiden. Center: Perseus. Below: Pegasus.

CLOVDS, MOVNTAINS, AND VOLCANOES

Clouds in tattoos may appear as scenery accompanying the sun, moon, or mythical creatures, especially in traditional Japanese tattooing, where they are an important element.

Appearing on their own they might suggest the heavens, since clouds often appear in religious artwork providing seating for God (or gods) and angels, or rain. Storm clouds point to nature's destructive potential, and when combined with lightening, may also signify thunder gods such as Zeus and Thor.

Specific mountains can point to their spiritual significance for the wearer, while a general image might imply a more Earth-based spirituality.

The high places of the world have always been associated with gods and spirits, for example the Himalayas, full of ancient stories of spirits and demons, and home of Tibetan Buddhism. Volcanoes have their associations with the gods Hephaestus and Vulcan in Greek and Roman mythology.

THE SEA

Tattoos of the sea might take the form of aquatic gods such as Neptune and Poseidon (see page 55), or feature more emblematic symbols that represent water, and therefore life.

Equally, the oceans are treacherous and can destroy just as much as they can create—think of Biblical stories of floods, for example. Nonetheless, we have a deep connection to the sea and it might make an appropriate design for those drawn to the water, either for work or worship. And if surfing is your religion, of course there is no better choice.

LOTUS

In the realm of spiritual tattooing you can't move without tripping over a lotus flower. It's hardly surprising, given its significance to many different faiths and mythologies.

To the Egyptians the lotus was the original flower from which the sun and gods emerged. For Hindus it is a symbol of purity that floats on top of water or mud without being stained, and is representative of the birth of Brahma, who appeared from a lotus flower growing in the navel of Vishnu. It's also an integral part of Buddhism since it symbolizes the Buddha's pure nature and forms part of the mantra *"om mani padme hum,"* which roughly translates as "hail to the jewel in the lotus."

EASTERN TRADITION
Lotus tattoos may exist alongside Buddha, Vishnu, or Shiva, to reflect Buddhist or Hindu beliefs. They can also appear as a standalone image or accompanied by the *om* symbol (see page 38), linking them to a more general spirituality influenced by Eastern tradition.

ROSE

Just as the lotus is sacred in the East, so the rose is at the heart of the flora of faith in the West.

FAITH AND LOVE

The links are mainly with Christianity, where the red of the rose (and its petals) is linked to the blood (and wounds) of Christ. A rose tattoo can remind Christians of Christ's sacrifice, but also his love for mankind. Roses are also closely associated with the Virgin Mary. However, roses are not the exclusive preserve of Christianity, and also have links to Greek and Roman mythology, where they were sacred to the goddesses of love, Aphrodite and Venus respectively.

A rose tattoo can signify either interpretation, as well as hinting at the beauty and potentially sharp, thorny danger of love in general—itself a kind of religion for some wearers.

CHERRY BLOSSOM

Cherry blossom forms an integral part of Japanese horimono tattooing, appearing alongside dragons, tigers, or other flora that represents spring, the season when the blooms open.

Transcience

It is this association with spring and brief blooming that gives cherry blossom its spiritual significance, whether it appears in isolation or as part of a larger tattoo. To the samurai cherry blossom represented both the beauty and the fragility of existence, reminding them that the perfect warrior soul must always be aware of how swiftly death may come.

Cherry blossom also ties in with Buddhist notions of impermanence; it arrives and departs in a fleeting moment, reminding Buddhists of the transient nature of life. The enlightened mind exists only in the present moment: appreciating the cherry blossom—real or tattooed—with no thought to its arrival or departure is a step toward that enlightenment.

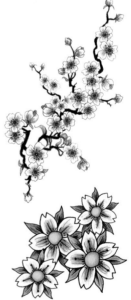

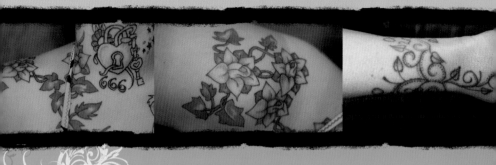

IVY AND VINES

Vines certainly have a party reputation when it comes to religious tattoos—grapevines might suggest Bacchus, the Roman god of wine, for example. Alternatively, Bacchus and his followers wore crowns of ivy, so ivy tattoos can be synonymous with him and also suggest revelry, immortality, and the age-old cult of Having A Good Time.

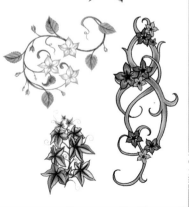

Cunningly, the symbol also contains a hangover cure, since ivy was believed to reduce the effects of wine.

When not representing Bacchanalian excess, the evergreen ivy has been a symbol of eternal life and resurrection to Christians, Romans, Druids, and Pagans alike. Its determined, winding ascent toward the heavens probably explains this, and it can obviously fulfill the same function as a tattoo that climbs up the body.

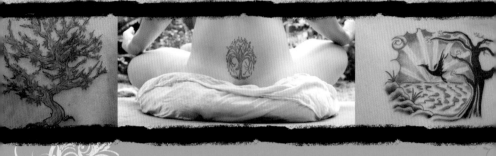

†REES

Whatever your tree tattoo, it can have as many spiritual interpretations as it does leaves.

A tree tattoo of any kind can be deeply spiritual, representing cycles of death and renewal in deciduous trees that lose their leaves every autumn, or eternal life in evergreens. Their roots below ground and leaves in the sky also make them emblems of heaven and Earth, linking the worlds of gods and men. They also point to the interconnectedness of all living things.

Specific trees can have particular meanings, for example the bodhi tree, which is revered by Buddhists as the site where the Buddha was enlightened, so a tattoo of one can represent the man himself or point to Buddhist beliefs in general.

†REES OF LİFE

The baobab tree, which stores water in its vast trunk, can live for thousands of years and is sometimes referred to as the "tree of life" in its native Africa. In fact there have been many trees of life throughout mythology and any can become tattoos. The Norse *Yggdrasil* was the world tree on which Odin hung, before collecting the runes to bring to mankind, while the Christian tree of life appeared in the Garden of Eden, and can symbolize Christ. There are also examples of trees of life or world trees in Mesoamerican cultures, as well as trees pointing to immortality in Chinese and Egyptian mythology.

OAK AND WILLOW

In addition, trees such as the oak and willow have their own particular significance. Sacred to Thor, Zeus, Native American cultures, and Druids, the oak is deeply rooted in the cultural consciousness and remains a byword for strength and endurance; the willow is sacred in Wicca and an emblem of the *bodhisattva* (compassionate being who has attained enlightenment) Kwan Yin in Buddhism, while maintaining a mournful or even sinister presence in English folklore. Whatever your tree tattoo, it can have as many spiritual interpretations as it does leaves. Treehouses, alas, aren't spiritual—just fun.

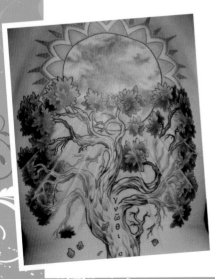

A large back tattoo combining the Earth, the sun, and an oak tree.

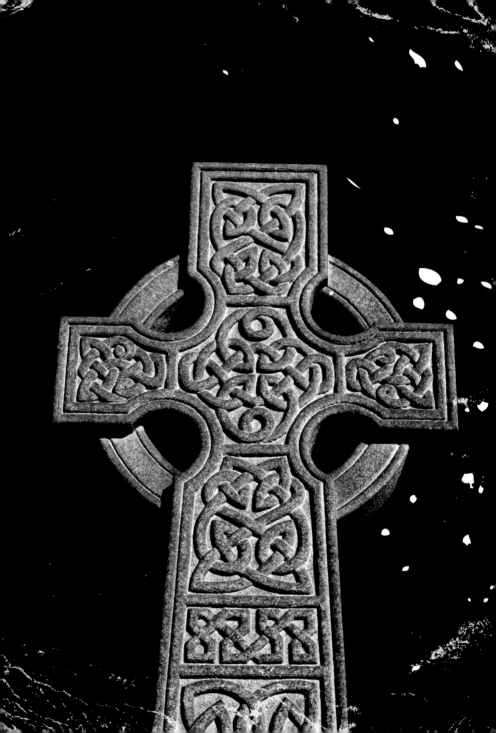

CELTIC

Celtic spirituality (including Christianity) is often said to have a connection to nature, embracing solitude and an edge-of-the-world feeling. Lonely standing stones and remote monasteries such as Iona and Lindisfarne reinforce this impression, as do the illuminated manuscripts once produced there, with their intricate knotwork and illustrations of plants and animals—all have found their way into tattoo art.

Celtic spiritual tattoos can cover a wide range of beliefs, encompassing Christianity, Druidism, Paganism, and Celtic-influenced New Age philosophies. Although the Celts once occupied Germany, Gaul (now France), parts of Spain and Italy, the Balkans, and Britain, today "Celtic" tends to refer to the Welsh, Scottish, and Irish nations, and tattoos can signify Celtic roots as well as spirituality.

CELTIC KNOTWORK

In the twenty-first century knotwork designs have come to be associated with Scottish, Irish, or Welsh culture. However, their origins are much further away, in the knotted mosaic patterns of the latter-day Roman Empire—but it's the use of step patterns, interwoven plaits, and knots in Celtic manuscripts and monuments that have really inspired tattoo designs over the years.

Although the exact meanings of early Celtic knotwork (if it had any) remain elusive, its loops and endless tanglings are reminiscent of the infinity and Ouroboros symbols, so in tattoos knotwork might signify eternal time or natural life cycles.

Armbands or ring designs reinforce this idea, combining the circle's unbroken loop with a never-ending knot to create a powerful symbol of eternity and binding commitment—making Celtic art popular for wedding ring tattoos. And even if you're not tying the knot in that way, these designs are enduring symbols of identity for those who belong to the Celtic nations.

THE BOOK OF KELLS

If you're looking for the ultimate Celtic art sourcebook for your ink, it's time to head to Ireland (and why not, it's lovely there) to gape at the *Book of Kells*. The fusion of Christianity and Celtic art finds its best expression in this stunning illuminated manuscript from the ninth century CE, believed to have been created and illustrated by Columban monks at the monasteries of Iona and Kells.

The book (which includes the four New Testament gospels) contains eye-wateringly complex knotwork and intricate decoration, along with figures of animals, plants, and men rendered in the Celtic style. It's one of the finest surviving examples of illustrative knotwork and has had a huge influence on Celtic tattoo art—not a bad achievement for some chaps in robes working by candlelight.

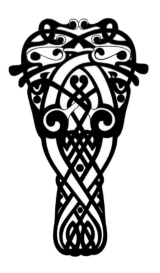

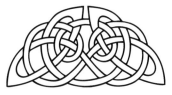

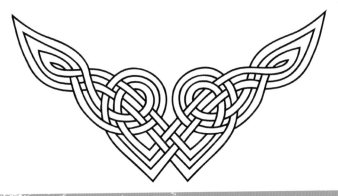

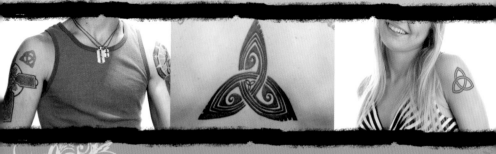

tRIQUETRA

Originally appearing as a decorative element in illuminated manuscripts like the *Book of Kells*, and in Norse stonework, the three-pointed triquetra has evolved to become a spiritual symbol, illustrating concepts containing threefold powers or qualities.

To Celtic Christians the interlocked leaves represent the holy trinity of God, Christ, and the Holy Spirit, all bound together. This meaning can be emphasised by adding a circle to the design, which links the three elements and carries its own symbolism of unity and eternity; it's also been suggested that the individual leaves resemble the "Icthus" fish symbol (see page 140).

The triquetra isn't uniquely Christian, though. Among other things it's embraced by Wiccans as a sign of the Triple Goddess, Pagans as a symbol of Sky, Earth, and Sea, and by those with Norse heritage who see the sign as having origins within their culture.

CLADDAGH

The Claddagh ring takes its name from a village in the Irish county of Galway, and has been in use since the 1700s as both a token of commitment and as a symbol of romantic availability. More recently it's also come to symbolize Irish nationality.

The design consists of a two hands (representing friendship) clasping a heart (symbolizing love), topped by a crown (meaning loyalty). The clasped hands design is similar to European fede rings (from the Italian *mani in fede*, "hands in trust") which have been in use since medieval times; the Claddagh, however, is uniquely Irish.

As a tattoo the Claddagh symbol carries the same general meanings of loyalty and betrothal, and that the heart is "held" by another. Unless you wear it on your left hand with the heart pointing away from you, that is—in its original meaning, this showed that you were "available." Generally Claddagh tattoos just embrace Irish symbolism, though, so don't worry about sending out the wrong signals. (Unless you're feeling romantically mischievous.)

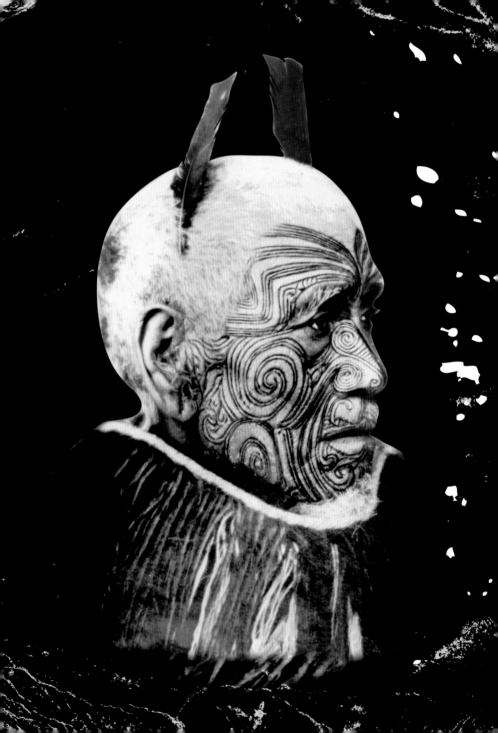

TRIBAL

For many cultures around the world, tattoos and tattooing have long provided a link to their spiritual heritage. The designs might signify ancestry, birthright, or rank, and act as protective talismans in life. In death, they might ease passage into the afterlife and even help the souls of the departed find their way.

Tribal tattooing is one of the most popular forms of inkwork and can be done by machine, or using traditional tools as part of an elaborate ritual where the process itself holds as much religious or spiritual importance as the finished tattoo. If you're looking for an authentic tribal tattoo it's vital to find an artist who fully understands the meaning and symbolism behind the designs, as they're often complex. This may of course involve traveling to an island paradise in Polynesia, but sometimes we have to suffer for our art...

MAORI

The Maori are the indigenous people of New Zealand. Their traditional tattoo culture, *moko* or *ta moko*, is considered *taonga*—a national treasure—and is an integral part of Maori heritage. It shouldn't be confused with *kirituhi*, a more modern and general term for skin art that may contain Maori influences.

Moko are distinctive geometric tattoos applied to the buttocks, thighs, and faces of men, and the noses and chins of women, although they may appear on other parts of the body. The traditional form is very different to other types of tattoo for several reasons, the main ones being:

• They are not placed under the skin by needles. Instead, they're chiseled or carved into the flesh, producing textured designs that are part tattoo, part scarification, although some modern artists do work with machines and produce *moko* in the same way as other tattoos.

• The designs contain very specific information about the wearer's tribe, genealogy (*whakapapa*), and cultural heritage, demanding a great deal of skill and knowledge on the part of the artist and the wearer.

ORIGINS

According to the Museum of New Zealand, *Te Papa Tongarewa,* the mythological origins of *ta moko* are based around the quarrel between wife and husband Niwareka and Mataora. Niwareka fled to the underworld to escape her husband's mistreatment, seeking refuge with her father's people. Mataora followed her in an attempt to win her back, arriving sweaty and unkempt from his exertions (it's not easy to reach the underworld in any culture). At this time the Maori merely painted their faces, so his decorations had smeared and he was roundly mocked by Niwareka's people, all of whom wore the *ta moko.* Begging forgiveness, he was instructed in the art of *moko* and returned with his wife, bringing the tattooing practice with them.

RESPECTFUL USE

The highly specific and personal nature of *moko* inkwork, as well as its deep roots within Maori culture, cannot be overstated. It's worn to assert Maori identity, and is a source of immense pride to the wearer, whether they choose to have the *moko* carved into their faces or not. Obviously this makes it an appropriate tattoo for anyone with Maori heritage and links to the mythology of *Aotearoa* (New Zealand), but there's ongoing controversy about the wearing of traditional *moko* by non-Maori people (although *kirituhi* is generally accepted). Needless to say, it's important to research this kind of tattoo carefully and give due respect to its origins and the culture it represents.

Two abstract depictions of Maori tattoos showcasing typically long, twining spiral features.

The three tattoo designs above use Maori-style striking spirals as inspiration. They expand on the traditional rounded and graceful spirals to create squared-off individualized designs.

The turtle, above, has been created using Maori influences. Although the turtle is not a traditional symbol in Maori tattoos, it has become a popular symbol in Western interpretations of the style. The simple striped band, below, is more in keeping with traditional Maori designs which would be painstakingly etched onto the faces of people of high rank.

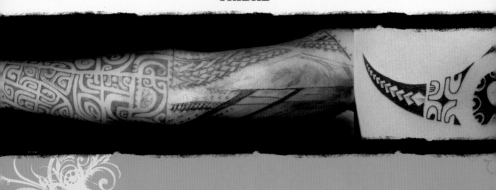

HAÏDA

The Haida tribe of the Pacific Northwest boasts distinctive red, black, and white art based on the totem animals of their mythology. These animals and myths transfer directly into inkwork, and create a unique kind of spiritual tattoo for those with Haida roots, or those who feel a kinship with their beliefs.

EAGLE AND RAVEN

Of the many creatures forming the pantheon of Haida totem animals, the most important are the eagle and the raven. The eagle carries many of the same associations as it does in the wider world, representing power and prestige, but it can also signify peace and friendship. The raven, on the other hand, loses its trademark Gothic shroud and gains a sense of humor, becoming the trickster bird that also stands for knowledge and creativity. In Haida mythology the

raven's pranks often end up helping mankind: he inadvertently teaches hunting and fishing, and releases the sun, moon, and stars, as well as—in some stories—letting mankind itself loose on the world. He exists as a salutary lesson in how not to behave and might fulfill the same function in tattoos, as well as appealing to those who love a prank or two.

MORE ANIMAL TOTEMS

Haida folklore includes many other creatures with different attributes. For example, the thunderbird brings about storms and lightning; the bear is aggressive and fearless, a warrior spirit; while the wolf represents hunting and healing. However, it's the sea that contains the most power, with the killer whale viewed as an aquatic version of the wolf and ruler of the sea, revered as a creature of terrible strength. In tattoo form these totem animals may transfer their characteristics to the wearer— although this doesn't mean that a killer whale tattoo will make sea lions your slaves, as the myth suggests.

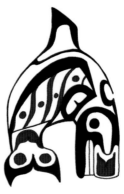

Top right: A Haida-style sun, released into nature by the raven. Center right: A whale, the Haida ruler of the sea. Below right: A dolphin, seen to be intelligent and harmonious in Haida culture.

NATiVE AMERiCAN

Native American tattooing can refer to inkwork hailing from the region once known as the New World, or the Americas, and includes examples inspired by Aztec, Inca, and other Mesoamerican cultures, as well as the Pacific Northwest. As these elements are covered elsewhere (see pages 62–63 and 208–209), this section focuses on North America.

A Native American tattoo might point to a particular heritage linked to the indigenous people of North America. As such, it could take the form of a portrait rather than an abstract symbol, showing a member of a particular tribe, and making an obvious statement about the wearer's roots. For those not seeking a portrait style, other images suggesting Native American mythology might appeal.

RELEVANT iMAGERY
The dreamcatcher is a popular image, representing the Spider Woman—a creator spirit who gave life to humankind in the stories of several tribes—at the center of creation, or perhaps signifying the sun

Above: A dreamcatcher.

caught in the her web every day at sunrise. It filters out bad dreams and only lets the good ones through, or changes bad dreams into good, depending on which interpretation you believe.

Medicine shields might be another option. These were circular and worn into battle by plains tribes who believed them to hold medicinal and protective powers. Attachments such as feathers may have been linked to guardian animals, but the full significance of a shield's design was only known to the wearer, making an image of one a perfect choice for a personal tattoo.

Designs of tomahawks, peace pipes, and buffalo skulls might suggest Native Americana, but like the *ta moko* (see pages 204–207) it's important to be cautious: some Native Americans take a dim view of clichéd imagery worn by those with no real connection to their heritage, so a thoughtful, respectful approach is required.

Top: A Native American carrying a medicine shield. Center: A highly decorated peace pipe. Left: A portrait of Native American depicting the power of nature.

BORNEO

The Dayak people (a term referring to many disparate tribes including the Iban, Kayan, and Kenyah) have ancestral roots in Borneo—the third largest island in the world—stretching back over many thousands of years. Although it's not known how long tattooing has been a part of their heritage, it's certainly true that the practice holds deep spiritual significance for the indigenous people of the island, and is still carried out in its traditional form today.

PROTECTION AND GUIDANCE

Dayak tattooing is inextricably linked to the natural world: the jungle and everything living in it. Designs might include insects and animals, but also representations of plants that are thought to have protective properties that the tattoo may confer on the wearer. They also illustrate the spirits—good and evil—that are believed to be present in every living thing, echoing the animist beliefs of the Dayak people.

Dayak-inspired tattoos might be bold, black designs showing living creatures and plants, or they could be protective arm- or wristbands designed to protect the wearer from harm (particularly in battle, as was the original

function). More abstract designs, especially if worn on the hand, may have another function: that of providing access to the afterlife and guiding the spirit of the deceased to the land of the dead. Less likely in the Western world is the use of tattoos to show how many heads the wearer has taken; definitely not an appropriate one for hairdressers.

Four Dayak-inspired bold tattoo designs focusing on nature's elements.

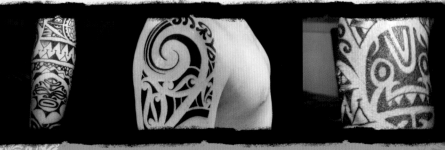

POLYNESIA

The island group known collectively as Polynesia comprises some 1,000 islands, including Hawaii, New Zealand, Tahiti, and Samoa. Even if the exact age of Polynesian tattooing is unknown, it's a matter of historical fact that international explorers such as Captain Cook commented on it when they first landed in Tahiti in the eighteenth century, by which point it was clearly very well established within Tahitian society.

SAMOA

According to Samoan myth, tattooing arrived from Fiji in the hands of two sisters, who carried tattoo instruments with them as they swam between the islands singing tattooing songs. A traditional Samoan tattoo (or *tatau*, one of the names from which "tattoo" is believed to have evolved) is known as a *pe'a* and consists of lines, motifs, and geometric patterns that, on a man, extend from the waist to the knees. For women it's called *malu* and covers the area between the knees and the tops of the thighs with slightly less intricate designs. Traditionally *pe'a* and *malu* tattooing denoted status and was vital to the warrior culture (a boy could not become a man until he was tattooed). Today, the tattoos are worn by people all over the world who wish to celebrate their Samoan heritage.

TONGA

Similarly, Tongan tattooing was intimately bound up with warrior culture and featured geometric designs mixed with solid swathes or bands of black; the tattooist was (and is) required to follow many rules in order to get the tattoo right.

TAHITI

While Tongan and Samoan tattooing prospered and influenced the art of the Marquesas Islands—contemporary portraits show Marquesan tattooing as highly sophisticated and involving a huge range of differing designs—tattooing in Tahiti faltered after European missionaries arrived. They condemned the practice as ungodly and it fell into decline, that is until a comparatively recent revival in the 1980s, which gave even "traditional" Tahitian tattoos a modern feel, though the Polynesian themes of warrior spirit and cultural heritage remain present in contemporary designs.

TRAVELING TATTOO

A Polynesian tattoo can point to roots in the islands, but is also often worn by those who have visited Polynesia, almost as a souvenir. This is frowned upon by some, but regarded by others as the natural evolution of a style of tattooing that has always traveled. After all, Europeans have been getting Polynesian inkwork since the time of Captain Cook (and possibly before). Either way, this influential style is an integral part of tattooing itself, and for that reason alone remains wildly popular among the inked tribe.

Three tattoo designs showcasing the multitude of detailed patterns in Polynesian culture.

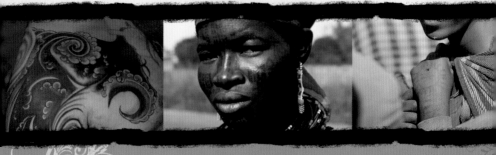

AFRICA

Where it exists, African tribal tattooing tends to be different to any other kind. The main reason is the method. Instead of needling the ink under the skin, African tribal artists use triangular blades to make incisions into to the face or other parts of the body, which ink or ash is rubbed into.

This method is every bit as painful as it sounds, and deliberately so, since the tattoos show the strength and fortitude of the person wearing them. Needless to say, you won't find many traditional African tattoo emporiums in your local community.

motifs

Traditional African tattooing involves several rounds—lasting weeks or months—of cutting, rubbing, and healing to produce the finished designs, so naturally these tattoos are not just intended as ice-breakers at parties. Instead they might indicate social rank or have religious significance, and take the form of arrows, lines, or dots.

Other more pictorial designs also exist. The women of the Maconde tribe in Mozambique traditionally bore images of trees, fruit, or lizards, which served the dual functions of attracting husbands and increasing fertility. There are also records of abstract symbols being used to ward off evil spirits, with tattoos on the back serving as protective shields.

While a modern ink collector may not want to undergo the slash-and-ash approach of traditional African tribal markings, it's certainly possible to find pictures of the designs and have them inked by machine, creating a modern version.

Four organic tattoo designs. Due to the complicated method employed, traditional African tattoo designs tend to be simple in form.

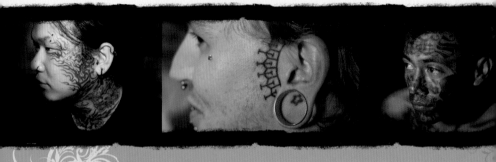

MODERN TRIBES AND GANGS

Gangs and the criminal underworld have had tattoos for as long as they've existed, and in that time they've developed complex meanings. There's even an interpretation of the Madonna and Child tattoo that signals the wearer is a lifelong criminal, using spiritual tattooing as a coded message to those in the know.

TATTOO CODES

Different gang cultures operate their own distinct tattoo codes. The Russian underworld is particularly complex, incorporating elements such as roses (often part of initiation tattoos), skulls (as a sign of high rank), and even crosses (apparently to show the wearer is a "prince of thieves"). In the United States a teardrop shows that a gang member has killed, or that they're mourning a fellow gang member killed in prison, while in Mexico the initials "MM" or a black hand might stand for the Mexican mafia. Even more subtly, three dots on the hand means "death to the cops" in France.

JAPANESE DEFIANCE

In Japan, tattooing is even more closely connected to the criminal element. As tattooing was outlawed for many years it naturally became a popular totem for *yakuza* gang members, who would sport full body suits to display

their strength as well as whatever symbolism the design implied. A tiger overcoming a dragon could suggest the darker side of the personality being dominant, for example. Although tattooing is now legal in Japan, many public places still ban those with visible tattoos as a result of the *yakuza* connection.

BELONGING

To end on a positive note, modern tribes or gangs can refer to anything that creates a sense of belonging in the wearer, including clubs, societies, and sports teams (and many would argue that sport is definitely a world religion). Tattoos of insignias, badges, and crests all display membership, both of the wearer's personal tribe, and the larger body that is tattooed people.

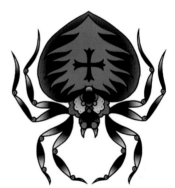

Gang members often use recognizable imagery in their tattoos—sometimes Biblical—to distinguish themselves.

THE ILLUSTRATORS

Danny Hirajeta is a freelance artist based in North Carolina, US. He runs Iron Clown Studios, a graphic arts studio bent on getting the best art to you for the soul purpose of world domination in the most artistic way possible. For more information check out www.theironclown.deviantart.com.

Jane Laurie spends most of her time drawing birds, and if she is not drawing them she will be outside with a pair of binoculars trying to find them. As well as illustration, Jane has also been involved with the design of interactive installation visuals, stage show design in London's West End, and stage imagery for pop star Mika. She is addicted to tattoos and has many plans to cover herself in more of them. To see more of Jane's work, visit www.janelaurie.com.

Emilie Jensen has been a working tattoo designer since 2002. Emelie stopped tattooing about two years ago and decided to stick with just designing tattoos, since this is where she felt her heart truly belongs.

Jon MDC can usually be found drawing or painting skulls in a field near his home in Hampshire, UK. He sometimes branches out and illustrates flowers and birds too. For further information check out www.godlovesawinner.blogspot.com.

Juli Moon Studio, located in Lynn Massachusetts, US, specializes in custom tattooing and creating unique works of tattoo art for the body. Juli herself is multi-award-winning and internationally recognized as a decorative tattoo artist as well as a leader in the field of cosmetic tattooing. Also contributing are Troy Talmadge who is a multimedia artist, painter, and experienced tattoo artist; and Jack Frazier, new to the world of tattooing, who brings an excellent artistic eye and an intricate knowledge of the tattoo machine.

Justin Nordine is the owner of The Raw Canvas Custom Tattoo Studio and Working Artist Gallery in Grand Junction, Colorado, US. His work has been praised by fellow artisans all over the world and has shown in several galleries. Justin's tattoo studio and art gallery fuses fine art and tattooing. Justin is married to his beautiful wife, Shauna and they have two children. Check out www.justinnordine.com or the tattoo studio and art gallery at www.therawcanvas.net.

Stuart Thomas hopes that, one day, he will be able to devote his life to drawing and painting anything he can from cartoons to landscapes, cars and bikes to gothic horror. And naked ladies. He lives in Somerset, England, with his wonderful partner, Michelle, and a houseful of cats who insist on eating his sketchbooks.

Abby Wilson is a freelance artist living in Boston, Massachusetts, US. Her work varies widely in medium and content, but most often depicts spiritual, Asian, traditional, and urban themes. For commissions or to order flash pages, contact her at awolartist@gmail.com.

INDEX